THE SPEEDLINERS

The Milwaukee Road's Hiawatha Steam Locomotives

Photos from the Roy Campbell Collection

Edited by Thomas E. Burg

Milwaukee Road Historical Association Steam Series
Volume 10

Merrill Publishing Associates

ISBN: 978-0-9832066-7-5

Copyright 2014, Merrill Publishing Associates, P.O. Box 51, Merrill, WI 54452

Published in association with the Milwaukee Road Historical Association, P.O. Box 307, Antioch, IL 60002-0307

All rights reserved. No part of this work may be reproduced or used in any form for commercial purposes by any means – graphic, electronic, or mechanical, including photocopying, recording, taping or any other information storage and retrieval system – without written permission from the publisher.

Design by Sharon Thatcher, Merrill Publishing Associates.

Printed in United States of America by Digi Copy, 1800 W. Stewart Ave., Wausau, WI 54401.

Front Cover: A class #2 and #3 bracket Speedliner-painted Pacific #6168 at the Milwaukee Everett Street depot. Train No. 21, the *Chippewa*, left Chicago just minutes before the *Afternoon Hiawatha*, and ran ahead of it to Milwaukee. To stay ahead of the *Hi*, the *Chippewa* was powered by one of the A's, in this case #3, which has been removed and is safely in the pocket track. The *Afternoon Hiawatha*, pulled by #2, has caught up and is taking water in its two-minute scheduled station stop before departing for the Twin Cities. Painted Pacific #6168 has replaced #3 on the *Chippewa* and here is getting under way for Green Bay and Iron Mountain.

Back Cover: Streamlined F7 class Hudson #104 rides the turntable at Milwaukee on October 16, 1938. The six F7's have been in town just a month, and will replace the A's on the ever-lengthening *Hiawathas*.

INTRODUCTION

In sidebar articles in 1947 *Trains* and *The Model Railroader* magazines, Kalmbach Publishing Company introduced Roy Campbell to its readers. Publisher Al Kalmbach hired longtime friend Campbell as the company's sales manager and goodwill ambassador following a chance meeting on a Chicago to Milwaukee train. The job was a hobbyist's dream – Campbell traveled the country (by train, of course), calling on railroad officials for *Trains*, on hobby shops and manufacturers for *The Model Railroader*, and on advertising agencies for both. He reported the results back to the magazines' editors and staffs.

Roy Campbell, 1955

Roy Campbell's background made him ideally suited for the position. Born in Houghton, Michigan, Campbell entered the insurance business at age 23 and worked his way up to the presidency of The Wisconsin Accident and Health Insurance Company. After the firm was sold, he successfully applied his interpersonal skills to the real estate business. He was looking for a new business venture at the time of his encounter with Kalmbach.

More importantly, Campbell was a railroad hobbyist himself. He was vice-president of the Railroad Society of Milwaukee and an avid railroad photographer. His artistic photographs won awards in exhibitions at Milwaukee's Layton Art Gallery and were published in *The Milwaukee Journal* and *Milwaukee Sentinel*. In addition to his own photography, he purchased from and traded with many other railroad photographers, amassing one of the largest and finest private collections in the Midwest.

Mr. Campbell died in 1965 and his collection lay dormant and largely forgotten for a quarter century. His grandson requested assistance from friend and railroad author Tom Burg in finding recognition for his grandfather's collection. Merrill Publishing Associates (MPA) has published a number of previous photo books and photo CDs from the collection, and MPA has produced nine books on Milwaukee Road steam locomotives for the Milwaukee Road Historical Association (MRHA)(www.mrha.com). This joint venture is Volume 10 of the MRHA Steam Series.

Thomas E. Burg received a Bachelor of Science degree in 1966 from Wilmington College, Wilmington, Ohio, and a Master of Science degree from the University of Idaho. He pursued a career as a Special Agent of the Federal Bureau of Investigation, retiring in 1999. Always a railfan and historian, Burg's initial retirement project was the authorship of *WHITE PINE ROUTE, The History of the Washington, Idaho & Montana Railway Company*, published by the Museum of North Idaho in 2003.

PREFACE

Speed! In 1934-35 speed was the basis of the competition between the three primary participants in the Chicago-Twin Cities passenger market – The C&NW, Burlington, and the Milwaukee Road. C&NW led off with its *400* – 400 miles in 400 minutes – using steam power and rebuilt conventional passenger equipment. Burlington countered with its *Twin Cities Zephyr*, an internal combustion powered, articulated stainless steel train designed to cover the distance in 6 ½ hours (390 minutes). The Milwaukee's plan became public in stages – first the exhibition of a lighter-weight passenger car designed for speed, and construction of a new fleet of cars in its Milwaukee shops. To match the Burlington's time, over a slightly longer route via Milwaukee, the road worked with Alco to design and build the first of the Speedliners. This was how they were known even before a public and employee contest and some skillful political maneuvering by C.H. Bilty, the road's chief mechanical engineer. The contest, of course, produced the fabulously successful concept of the *Hiawathas*, leading to an entire tribe of colorful steam-powered Speedliners – *Hiawatha, Morning Hiawatha, Afternoon Hiawatha, North Woods Hiawatha, Midwest Hiawatha,* and *Chippewa Hiawatha*.

Beginning in 2004, Merrill Publishing Associates (MPA) produced and the Milwaukee Road Historical Association (MRHA) published a planned ten-volume series of photo books on the different classes of Milwaukee Road steam locomotives, sharing photos from the Roy Campbell Collection. The final volume of this series was always reserved for "*Hiawathas* and *Chippewas*". As the time for this volume arrived, it became clear that there was far more material than could be contained in a small volume matching the first nine. The result was this joint venture produced and published by MPA as both the tenth volume in the MRHA series and as a stand-alone photo book of the Milwaukee Road's Speedliner locomotives and passenger trains. Though lasting only a dozen years in steam power, the *Hiawathas'* color, flair, and speed are still viewed by many as the premiere accomplishment of "America's Resourceful Railroad."

Jim Scribbins provides the trains' history in *The Hiawatha Story*. Roy Campbell's presence on the Milwaukee scene to photograph the locomotives and trains in everyday service, his connections with the railroad for company photos, and his stature in the community of rail photographers allowed him to amass this collection of photos, presented here for the viewer to explore and enjoy. Where photographers other than Campbell are known, they are credited at the end of the photo captions.

The editor wishes to acknowledge the assistance of Ralph Wehlitz, MMR, in the preparation of this volume.

This book is organized by locomotive type – the original A class Atlantic (or Milwaukee) type, subsequent F7 class Hudsons, G class ten-wheelers, and various F class Pacifics both streamlined and brightly painted to pull the famous Speedliner trains.

MESSAGE FROM THE PRESIDENT

With this 10th and final volume on the Milwaukee's Road's famous *Hiawathas*, we conclude our series on the steam locomotives of the Milwaukee Road. We would be remiss if we did not recognize those who made this series possible, and added to the historical context of the railroad. We are extremely grateful to the owners for providing the material from the Roy Campbell Collection for a comprehensive look at the various types of locomotives owned and operated by the Milwaukee. We are also indebted to Tom Burg for his editing of this series and for the many other ways he had contributed his time, energy and knowledge to the Milwaukee Road Historical Association. We are also very appreciative of the efforts and professionalism of Sharon Thatcher who has laid out the design, graphics and styling for the books. Finally, we are thankful to Ralph Wehlitz for his efforts to insure the accuracy of the material in all the books of the series. It is our sincere hope that we will find other projects to work on with this outstanding group of people.

We will continue to produce more material on the Milwaukee Road as time goes on, so our readers can look forward to more interesting topics in the future. However, we hope that this series has enhanced your interest in the Milwaukee Road and we encourage you to become a member of our organization. Through our excellent quarterly magazine, *The Milwaukee Railroader*, we share and preserve the history of one of America's great and unique railroads. In addition, we provide video and other materials to expand on that history, and the history of the many smaller railroads that became a part of the Milwaukee's system. We also have many resources available through our website to answer questions about the Railroad or how to model its structures, locomotives or rolling stock.

Join us, and our over 2,700 members, online at our website, www.mrha.com or by writing to our postal address listed on the copyright page, and help us not only provide information and resources for today, but preserve them for the future.

We appreciate your support of the work of MRHA through your purchase of this book.

Bob Storozuk, President
Milwaukee Road Historical Association

TABLE OF CONTENTS

INTRODUCTION 3
PREFACE 4
TABLE OF CONTENTS 5
MESSAGE FROM THE MRHA PRESIDENT 5
A CLASS ATLANTICS 6
F7 CLASS HUDSONS 50
G CLASS TEN-WHEELERS 72
F CLASS PACIFICS 80
PASSENGER CARS 106
ROSTER OF SPEEDLINER LOCOMOTIVES 111
BIBLIOGRAPHY 113
MERRILL PUBLISHING ASSOCIATES 114

The Speedliners

A Class Atlantics

The first Speedliner locomotives specifically designed for the new high-speed lightweight trains were of the 4-4-2 wheel arrangement, one not constructed in the United States in twenty years. These largest Atlantics ever built, however, were not your grandfather's Atlantics, having 300 psi boiler pressure, 84" drivers, longer wheelbase with main rods connected to the first Boxpok drivers, roller bearings, and streamlined shrouding with eye-catching colors. Built for speed, they produced 3000 sustained horsepower at high speeds. #1 was the first one to break the barrier at the Alco plant and become public on April 30, 1935, and #1 and #2 arrived on Milwaukee rails in early May. After testing and shakedown, they went into regular service pulling the *Hiawathas* between Chicago and the Twin Cities on May 29, 1935. #3 arrived in 1936 and #4 a year later. When displaced they took over the *Midwest Hiawathas*.

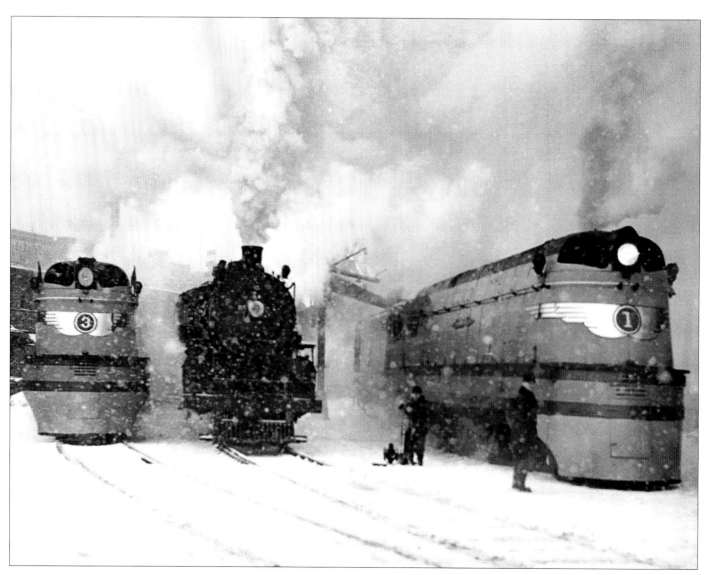

Streamlined A class speedliners #1 and #3 flank a conventional Pacific on a snowy January 4, 1938, at the Milwaukee depot. #3 has just come off the first section from Chicago (No. 21, the *Chippewa*, running as First No. 101) and still carries its green flags. It has been replaced by the Pacific, which is about to depart for Green Bay and points north. The second section behind #1, now taking water, has become "first" No. 101, the *Afternoon Hiawatha*, soon to depart for the Twin Cities.

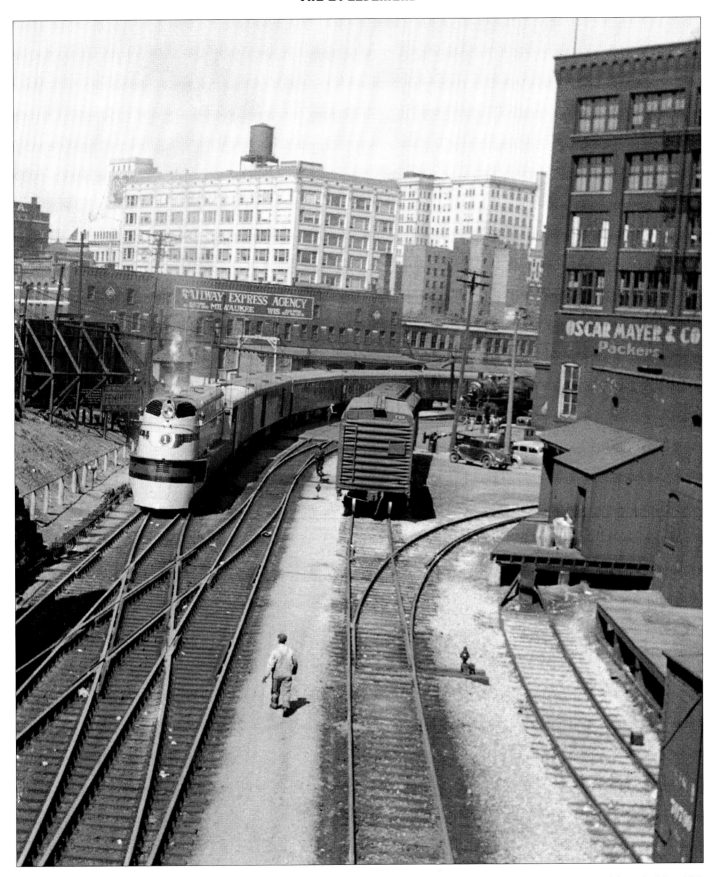

#1 departs the depot westbound around the sharp curve and through the double crossover in July 1936 with train No. 101, the *Hiawatha*. This view from the Sixth Street viaduct also captures the Oscar Meyer sign and industrial sidings at right.

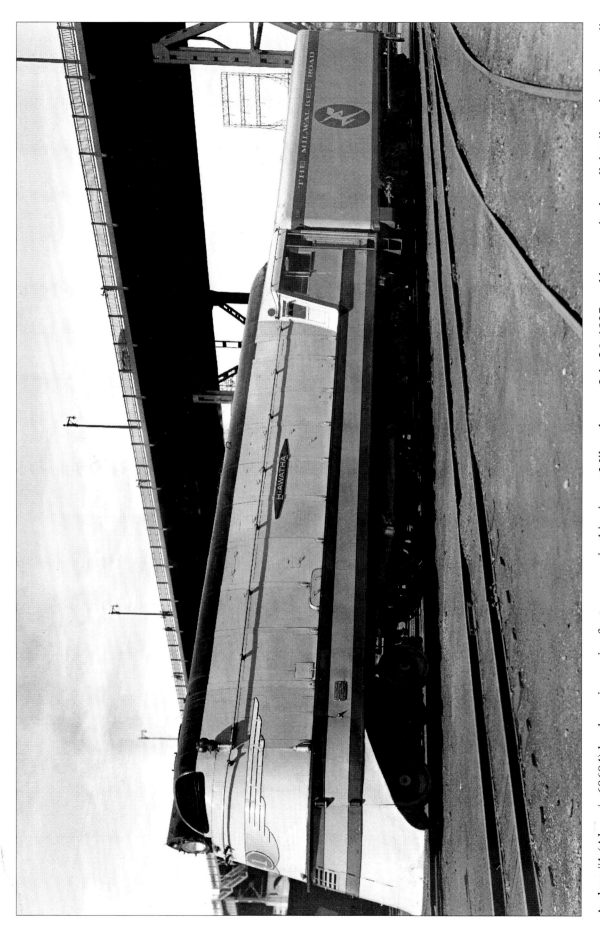

A class #1 (Alco c/n 68684) has been in service for two years in this view at Milwaukee on July 26, 1937, and has acquired small details such as the small round "porthole" window above the front cab window to allow observation of the stack exhaust while operating, handrail on cab roof, walkway and stripe below the cab windows, and the *Hiawatha* logo on the tender flank. The train steam heat line is above the rear tender truck; it was relocated out of sight underneath on #3 and #4. Milwaukee Road photo.

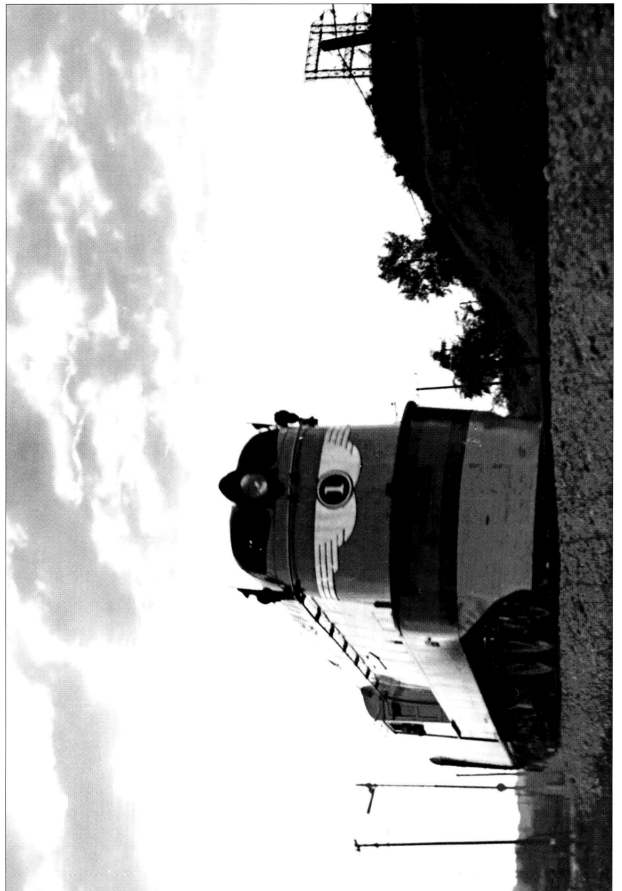

#1 carries flags indicating a section following as it swings inbound to Milwaukee around the shops curve.

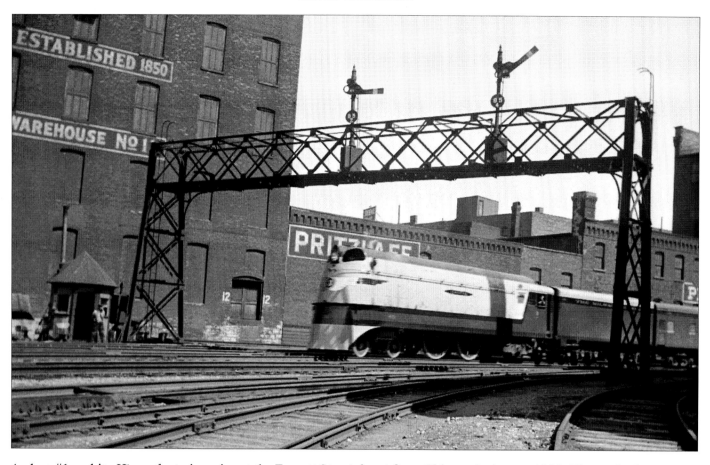

A class #1 and its *Hiawatha* train arrive at the Everett Street depot from Chicago in August 1936. The tender has not yet acquired its *Hiawatha* logo. Warehouses of Pritzlaff Hardware dominated the backdrop east of the depot.

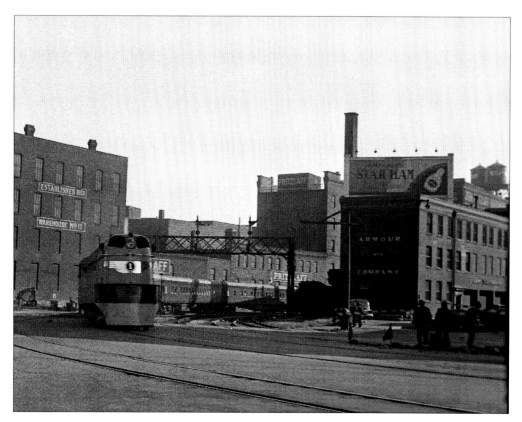

#1 curves into the depot in snowless January 1936. The *Hiawatha's* running time for the 85 miles from Chicago was 75 minutes.

The Speedliners

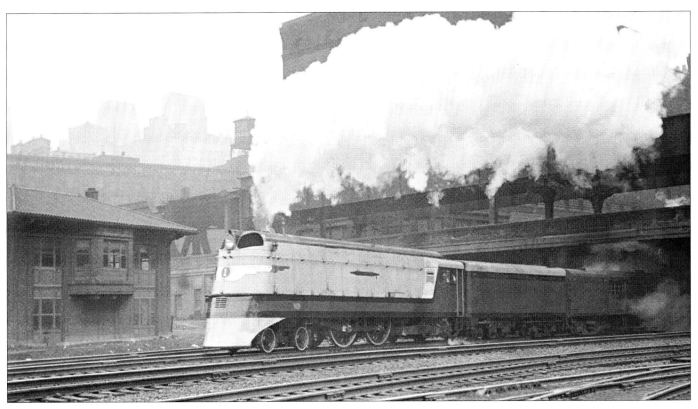

#1 departs Chicago Union Station under the Lake Street "L" and past the Lake Street Tower. The class A 4-4-2's had 19" x 28" cylinders, 84" drivers, 300 psi maximum boiler pressure and 30,685 pounds tractive effort (TE).

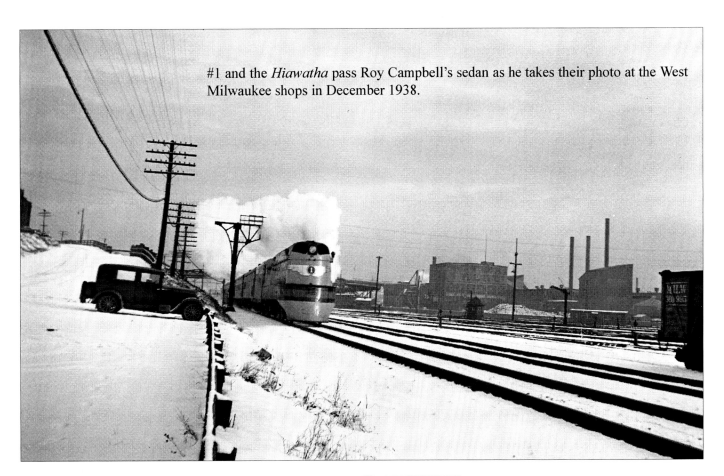

#1 and the *Hiawatha* pass Roy Campbell's sedan as he takes their photo at the West Milwaukee shops in December 1938.

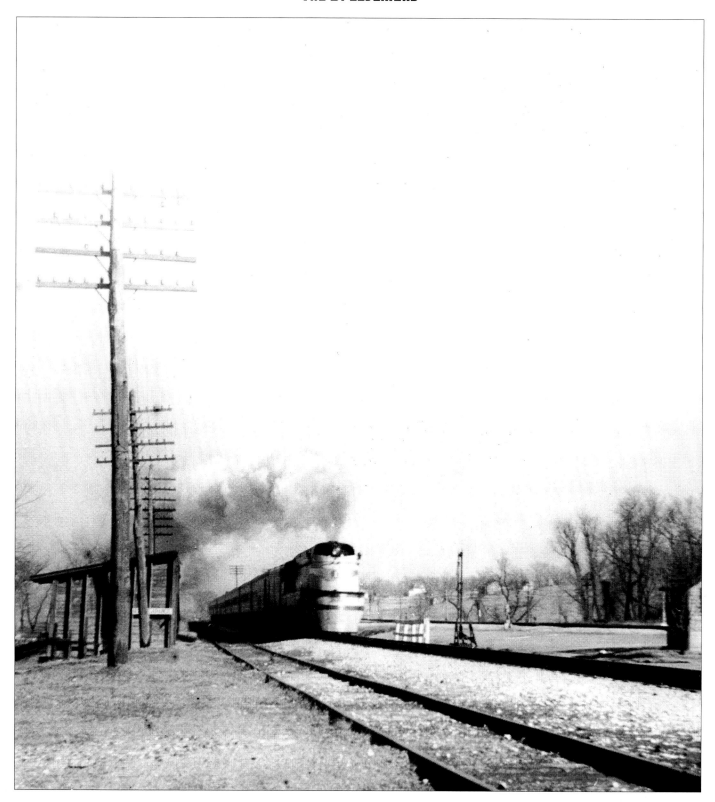

A *Hiawatha* at speed approaches Wauwatosa. A 1935 Milwaukee Road travel brochure described the *Hiawatha* as "The first of the Speedliners," and "America's first integral streamlined steam locomotive and the newest type of stream-styled super-speed train." All axles on the locomotive, tender, and cars had roller bearings. The tender roofline was the same as the cars, providing a single-unit appearance. The cars' reduced weight improved the horsepower to weight ratio.

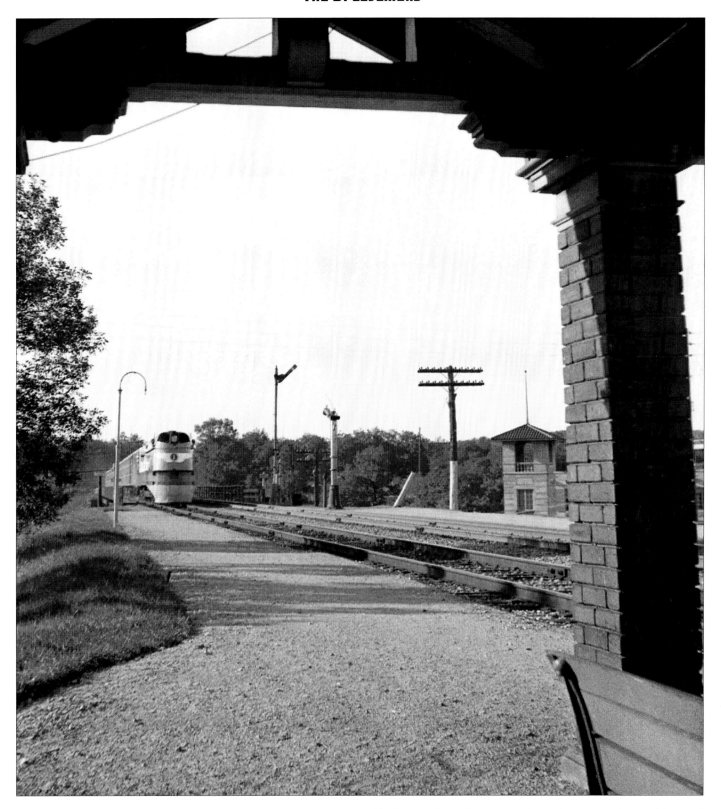
The passenger shelter on the eastbound main at Wisconsin Dells frames #1 as it crosses the Wisconsin River bridge and passes through quickly in August 1939.

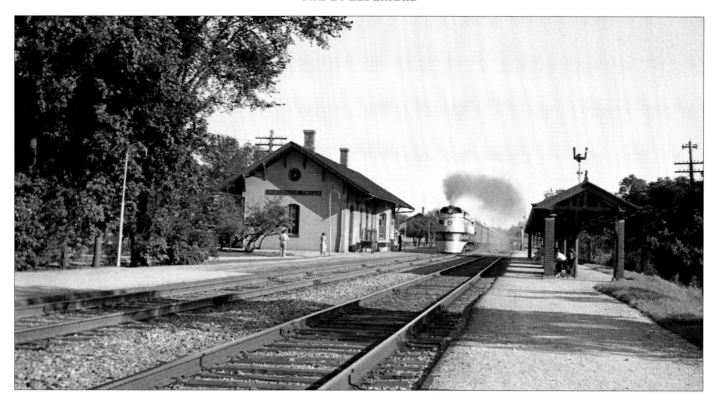

The *Hiawatha* made very few stops on its race from Chicago to the Twin Cities, and Wisconsin Dells was not one of them. Streamlined #1 kicks up dust from new ballast as it roars through on September 24, 1935. To handle the train's speeds, trackwork received special attention, including 132 pound rails. The signal blocks were lengthened and circuits altered to allow two clear blocks ahead of the Speedliners.

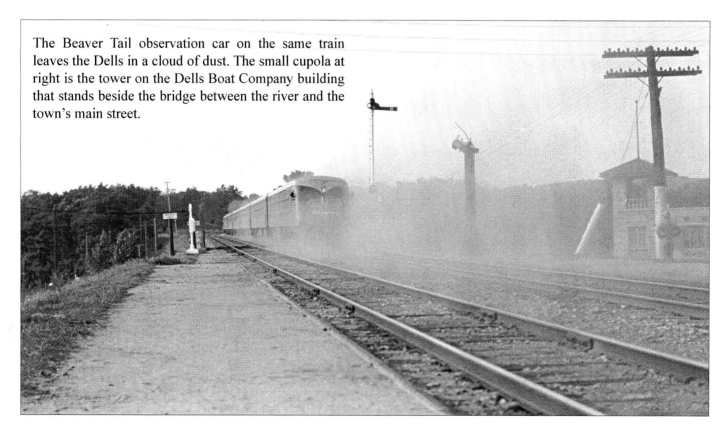

The Beaver Tail observation car on the same train leaves the Dells in a cloud of dust. The small cupola at right is the tower on the Dells Boat Company building that stands beside the bridge between the river and the town's main street.

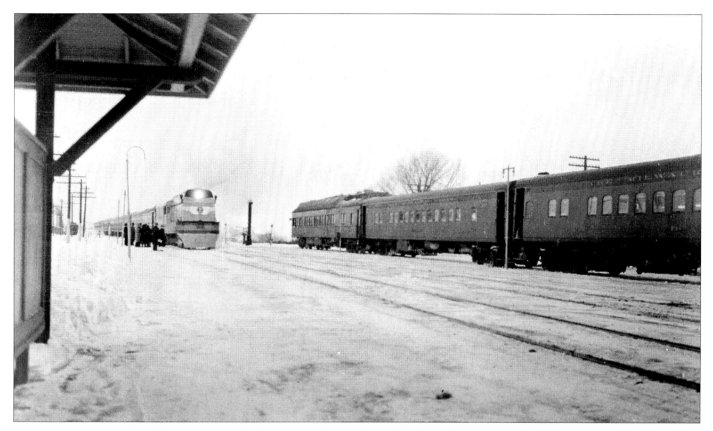

Eastbound #1 eases to a stop at snow-covered New Lisbon on January 8, 1937. New Lisbon was the change point for Valley Line trains and all-stops locals for points between the *Hiawatha's* stops. Milwaukee Road photo.

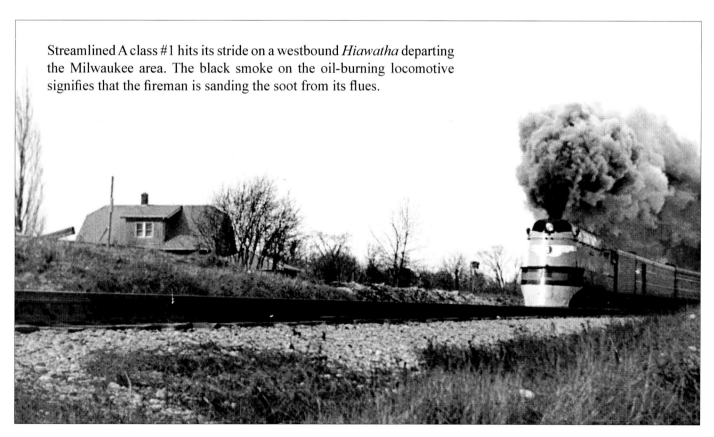

Streamlined A class #1 hits its stride on a westbound *Hiawatha* departing the Milwaukee area. The black smoke on the oil-burning locomotive signifies that the fireman is sanding the soot from its flues.

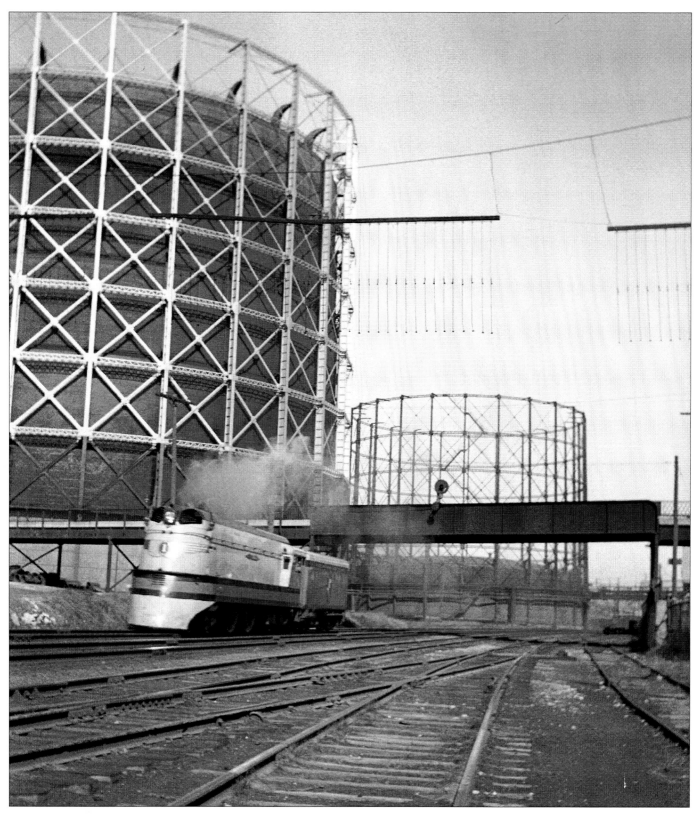

#1 passes the City of Milwaukee's gasholders on March 26, 1938. Gasholder tanks deflate (background tank) as gas is consumed. The locomotive and tender in working order weighed 527,000 pounds, larger than any Pacific on the Milwaukee roster.

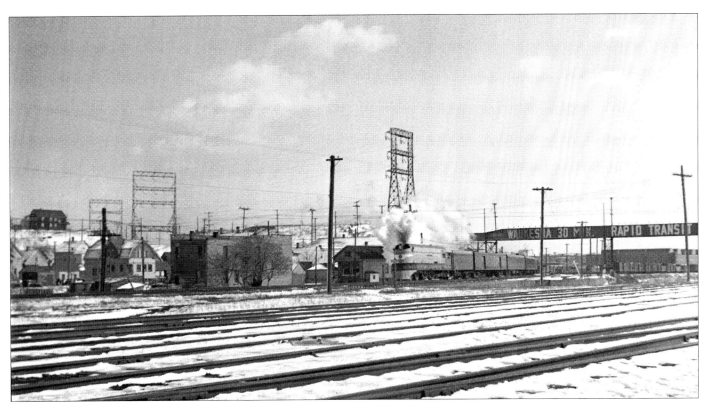
Around the curve from the shops the main line passes under the interurban line of The Milwaukee Electric Railway and Light Company. Speedliner #1 steams by in March 1936.

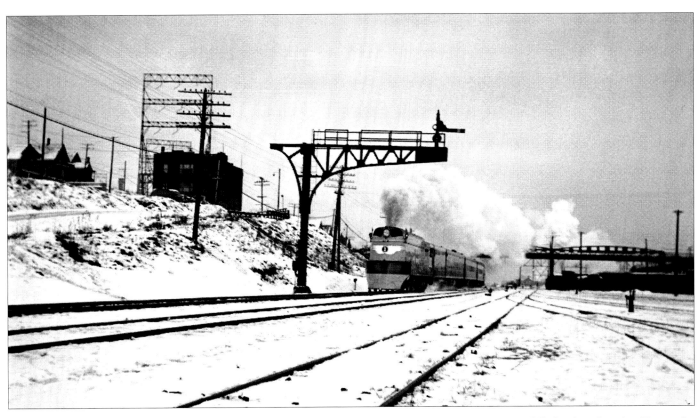
The west side cantilevered signal bridge carries a semaphore signal rather than the later searchlight signal as the *Hiawatha* approaches with #1 on the point in February 1936.

The Speedliners

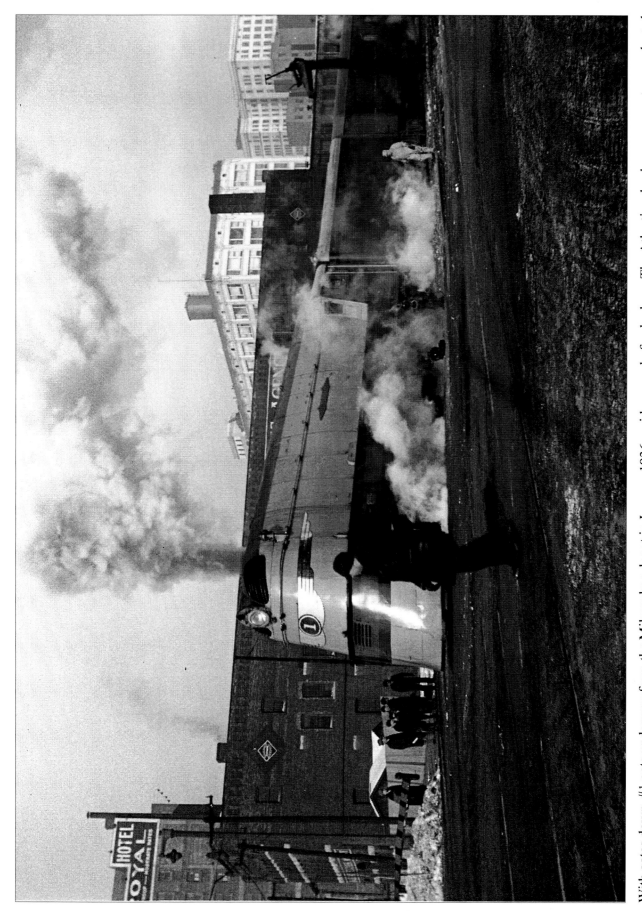

With gates down, #1 gets underway from the Milwaukee depot in January 1936 amid a crowd of onlookers. The Atlantic wheel arrangement was selected by company engineers to maximize speed with minimum weight of reciprocating parts. They dubbed it the "Milwaukee Type". It was the largest 4-4-2 ever built.

THE SPEEDLINERS

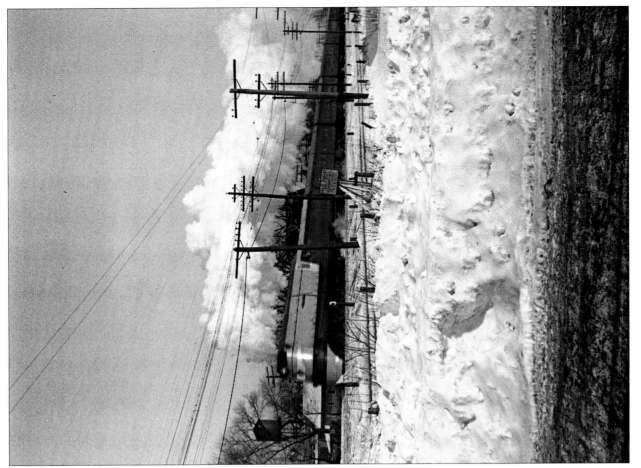

In contrast, the Wauwatosa landscape in February 1936 is covered with snow as the *Hiawatha* glides by.

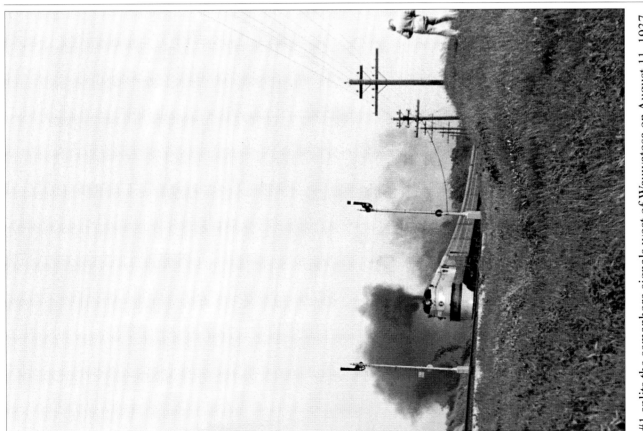

#1 splits the semaphore signals west of Wauwatosa on August 11, 1937.

The Speedliners

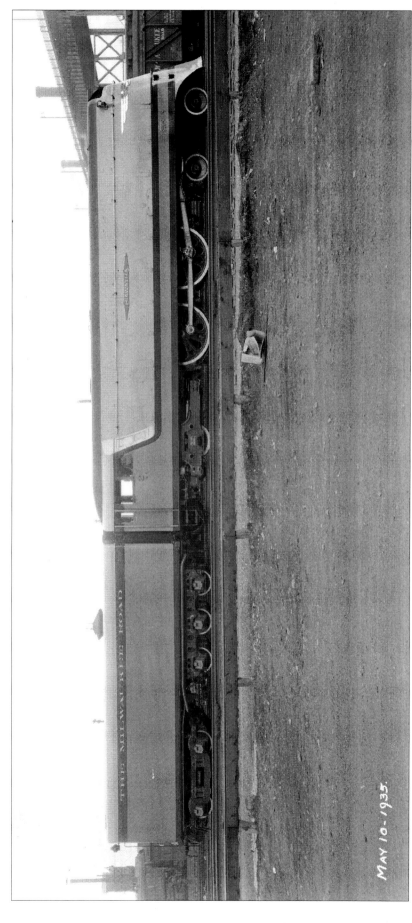

To keep up with modern design ideas, Milwaukee Road engineers decided upon a streamlined design for the locomotives of the new train, and the class A Atlantics were the first streamlined steam locomotives designed from the beginning as such. Streamlining had advantages other than appearance. Wind tunnel tests proved the rounding, sloping, and removing of projections provided 35% less air resistance than a conventional locomotive. #2 (Alco c/n 68685) has just arrived in Milwaukee from the Alco factory on May 10, 1935, and is in its original state without tender logo or cab side handrails and running board, and lower cab stripe. As designed, the top maroon stripe flowed up over the cab windows and became the letter boards for the tender and cars. Milwaukee Road photo.

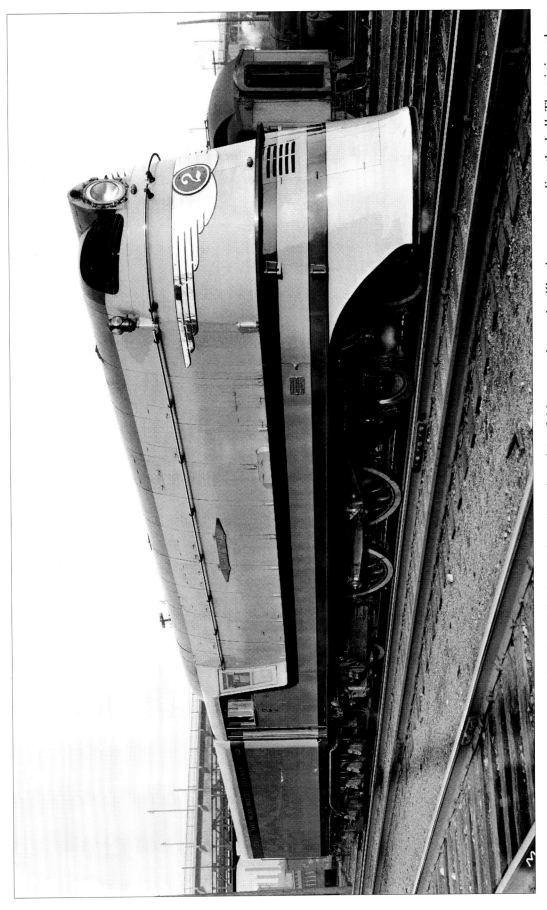

This view of new #2 taken the same day shows the front winged number plate, fold-up coupler, and grille above, concealing the bell. The piping above the front truck of the tender is the train's steam heat line. The 84" Boxpok cast drivers and nickel-steel rods reduced weight and were both easier on the rail and easier riding. The shrouding hides Walschaert valve gear. Milwaukee Road photo.

THE SPEEDLINERS

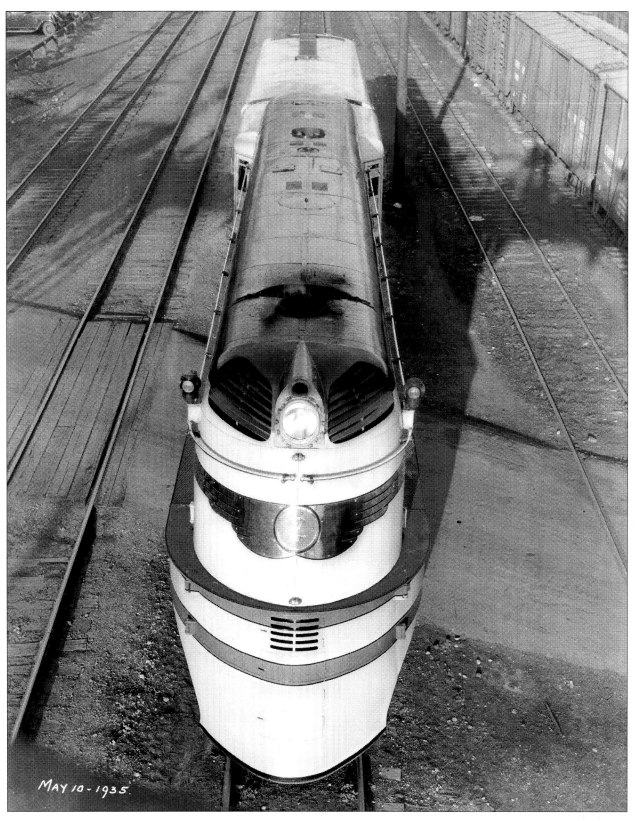

Viewed from above that day, #2 shows the headlight, black cowling covering the domes, and stack. The front grilles beside the headlight took in air and exited it just behind the stack, functioning as a smoke lifter to raise smoke above the cab. The air horn is just above the headlight. Milwaukee Road photo.

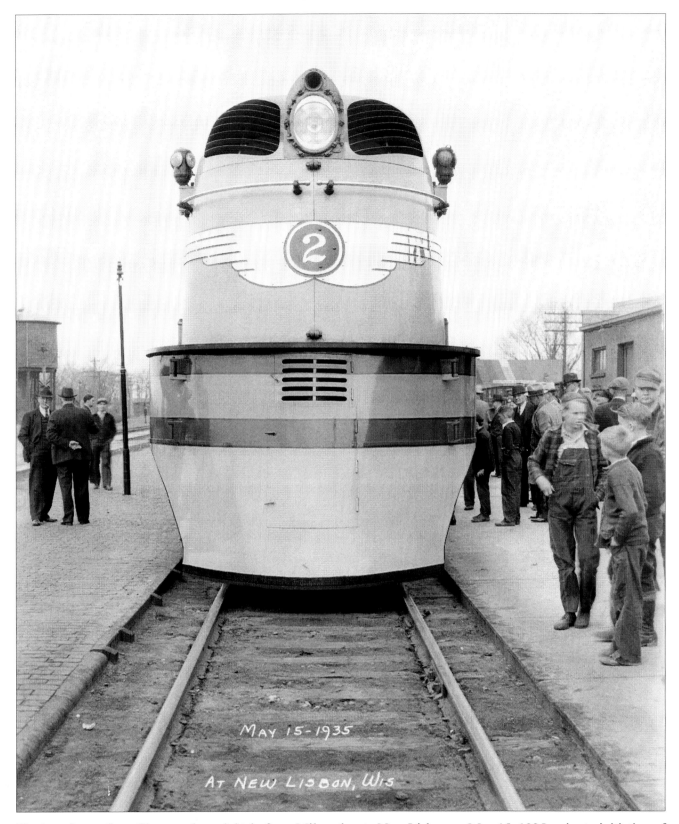

The brand-new Speedliner made a trial trip from Milwaukee to New Lisbon on May 15, 1935, prior to initiation of service. Word leaked out and at New Lisbon schools closed and the entire town turned out to see #2 and tour the train, here parked on the Valley Line stub. Milwaukee Road photo.

THE SPEEDLINERS

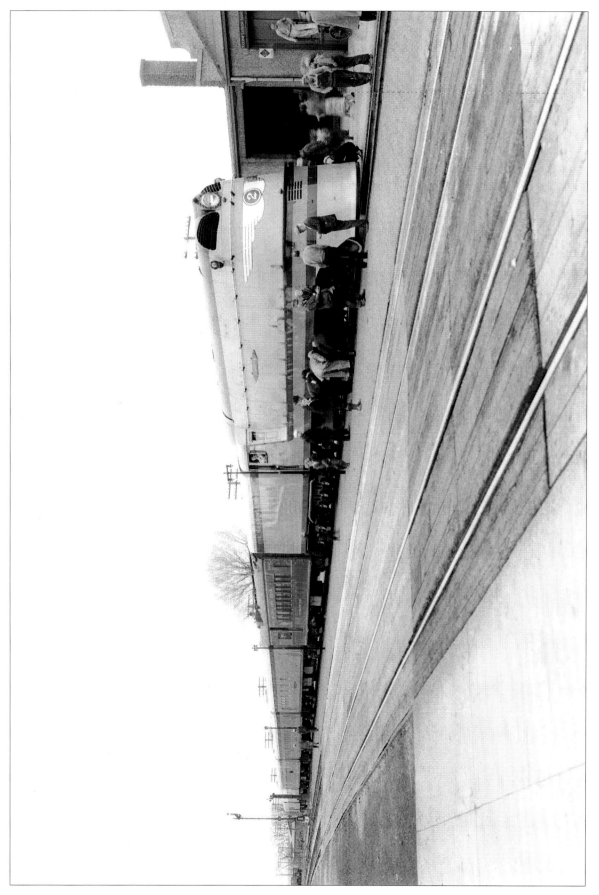

The demonstration train, here parked at the New Lisbon depot and being inspected by citizens and railroaders alike, carried the company dynamometer car. It measured speeds over 100 mph. Milwaukee Road photo.

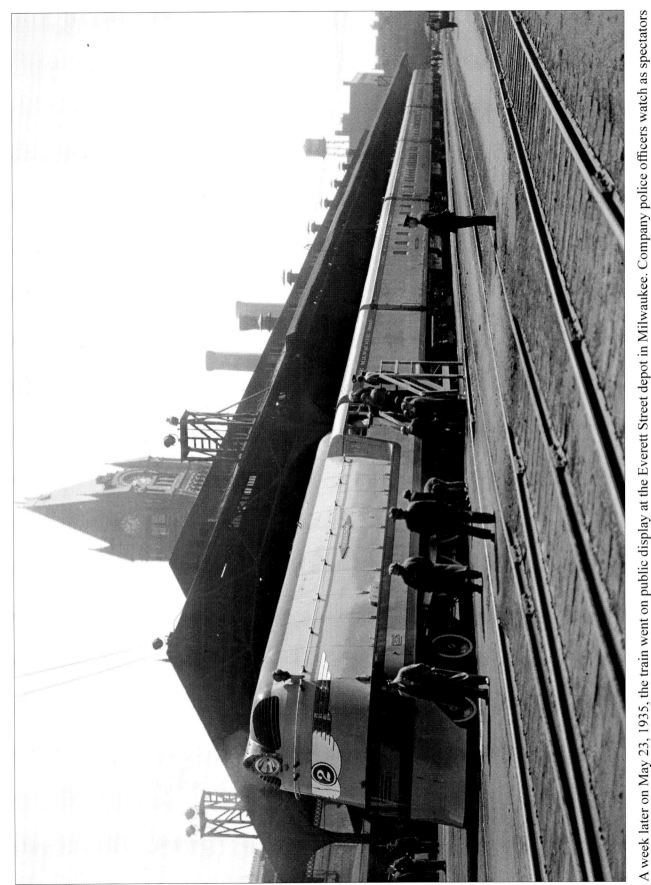

A week later on May 23, 1935, the train went on public display at the Everett Street depot in Milwaukee. Company police officers watch as spectators climb to the vestibule cab, which featured sound deadener and insulation, air circulation and steam heat in winter, and cab signals. It contained four seats, two on each side. Milwaukee Road photo.

The Speedliners

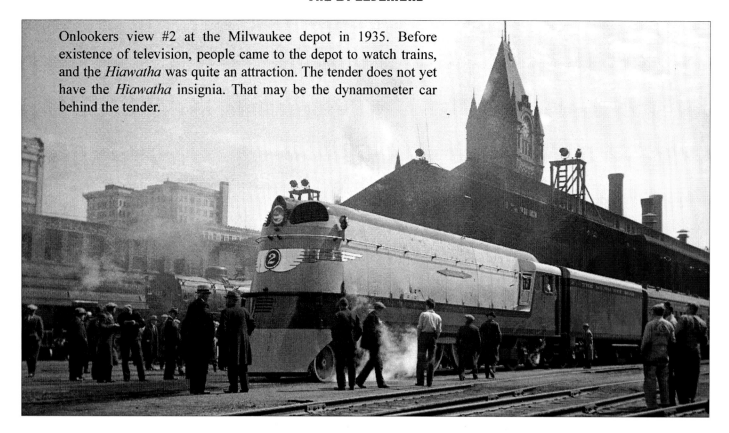

Onlookers view #2 at the Milwaukee depot in 1935. Before existence of television, people came to the depot to watch trains, and the *Hiawatha* was quite an attraction. The tender does not yet have the *Hiawatha* insignia. That may be the dynamometer car behind the tender.

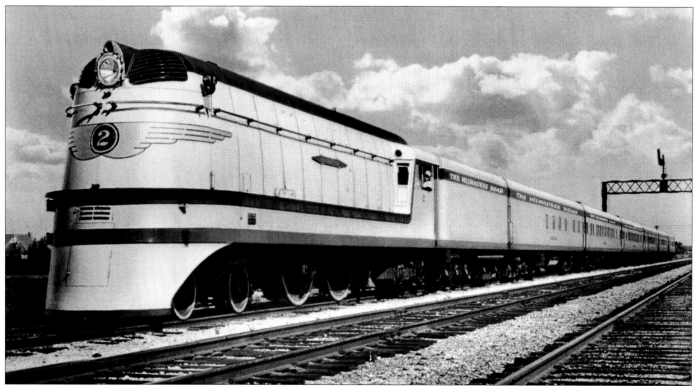

Company publicity photo of #2 with its six-car train, which consisted of Tip Top Lounge car, three coaches, parlor car and parlor observation car; total seating was 313. The cars were the same height and contour as the tender roof, cutting down wind resistance. Cost savings in construction of the lightweight cars paid for the locomotives. Milwaukee Road photo.

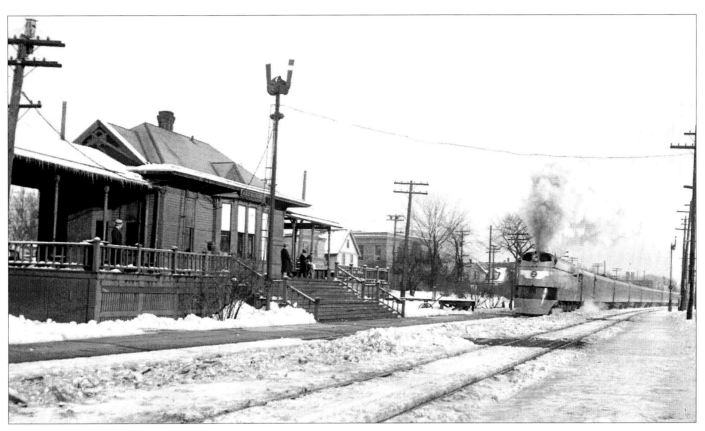
The *Hiawatha* with #2 in charge steams past the picturesque Wauwatosa depot in January 1936.

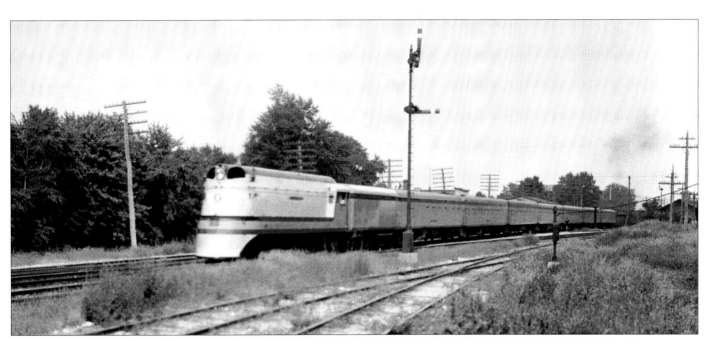
#2 has a clean fire as it passes Brookfield on July 3, 1935 with a month-old No. 101 (first section). The *Hiawatha* is expanded to seven cars with a fourth coach, and a second section follows. The Brookfield depot is in the distance at far right, and the branch to Waukesha is in the foreground at lower left. The lower signal is the advance signal for the freight line that diverges at Elm Grove. Milwaukee Road photo.

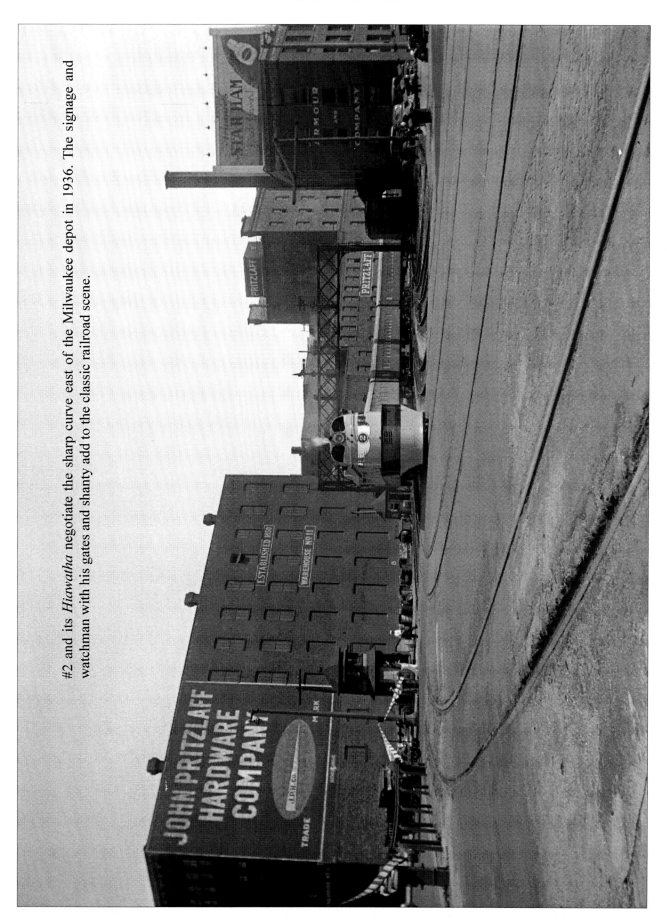

#2 and its *Hiawatha* negotiate the sharp curve east of the Milwaukee depot in 1936. The signage and watchman with his gates and shanty add to the classic railroad scene.

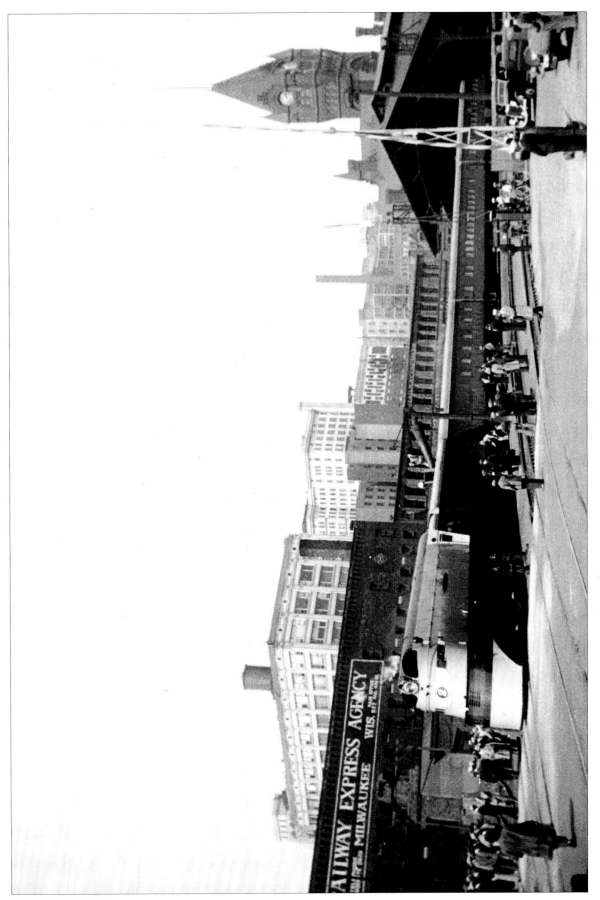

It is 2:15 pm and train No. 101 has just arrived from Chicago. Onlookers watch #2 take water in its quick stop at the Milwaukee depot. The next water stop will be at LaCrosse.

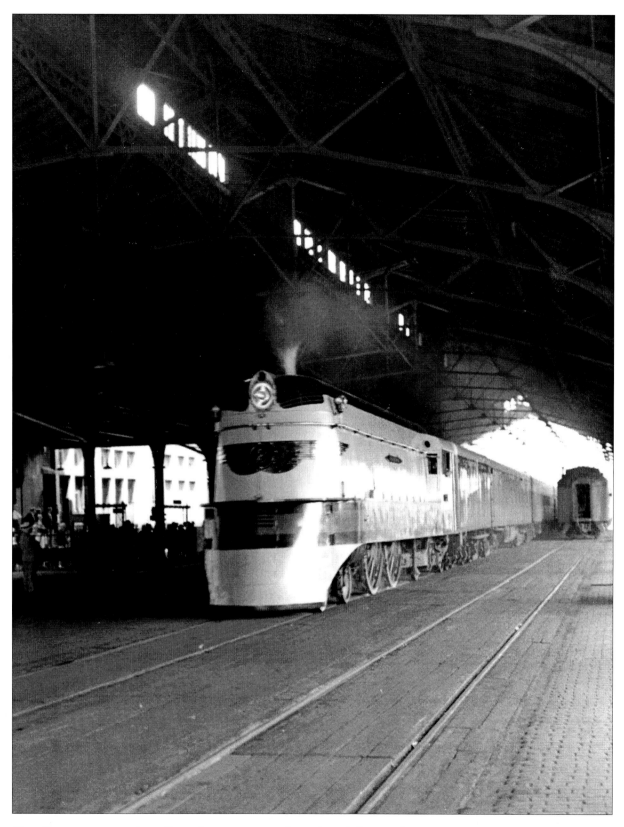

#2 rolls to a stop as a long line of passengers waits to board the westbound *Hiawatha* inside the trainshed in Milwaukee. The cars were 33% lighter than the heavyweight cars of the day, and their 18" lower height and lower center of gravity offered passengers a better ride.

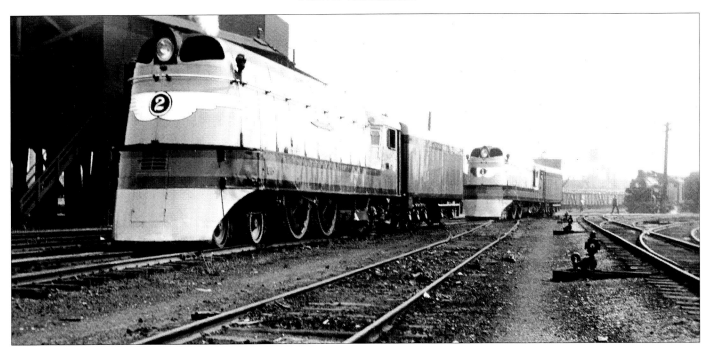

In the Chicago engine terminal, #2 in the foreground and #1 behind constitute the road's entire roster of Speedliners ca. 1935-36. In contrast to their streamlined contours, the locomotives carry traditional classification lamps.

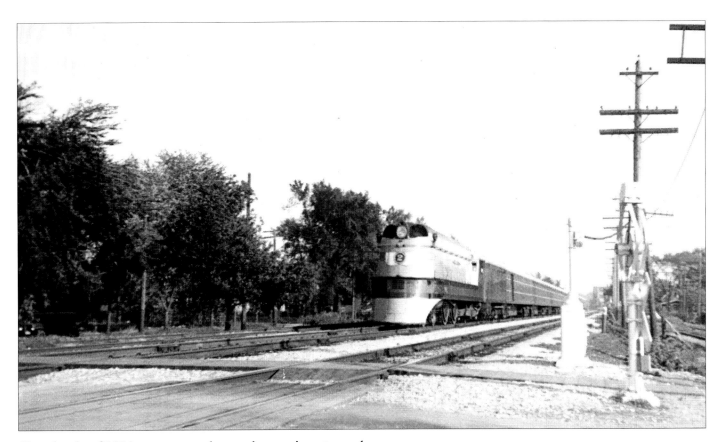

#2 and train of 1938 cars approach a grade crossing at speed.

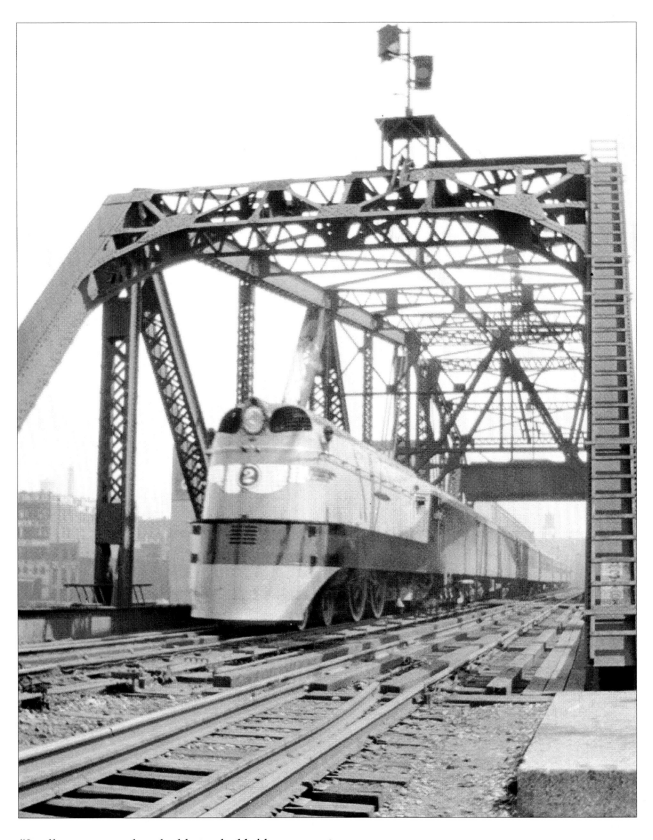

#2 rolls across an urban double-tracked bridge.

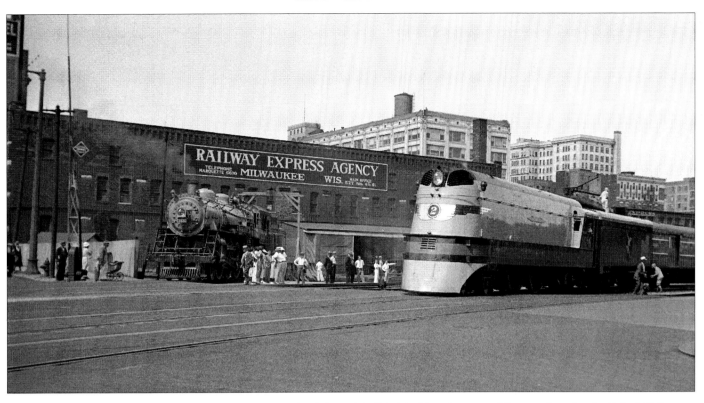

The fireman on #2 takes water in the depot, and colorful Pacific #6139 rides the turntable on a hot day in July 1937.

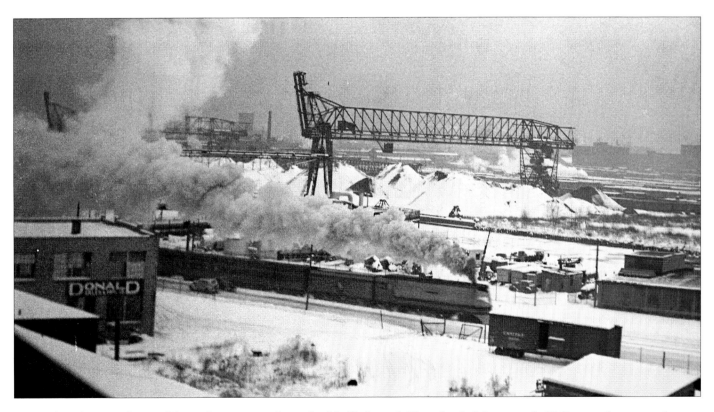

An A class locomotive and its train are seen from the bluff above Milwaukee's Menonomie Valley as they pass the gas company coal pile and unloader.

THE SPEEDLINERS

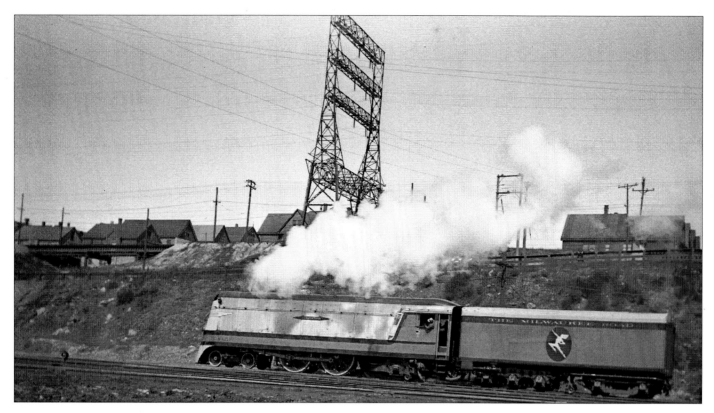

#2 glides past at West Milwaukee in March 1938. The overall length of the locomotive and tender is 88'8". Tender capacity was 13,000 gallons of water and 4,000 gallons of oil. Refueling occurred at each end of the trip.

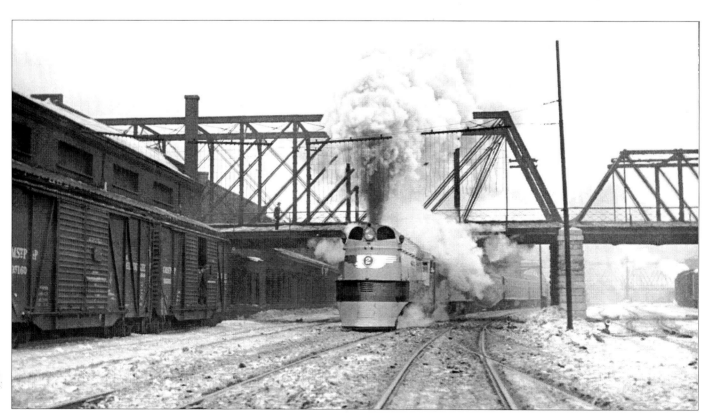

#2 is already at speed as it passes under the Sangamon Street viaduct departing downtown Chicago on February 22, 1936. The dirty soot is from the many coal-burning locomotives, not the oil-burning A's.

The Speedliners

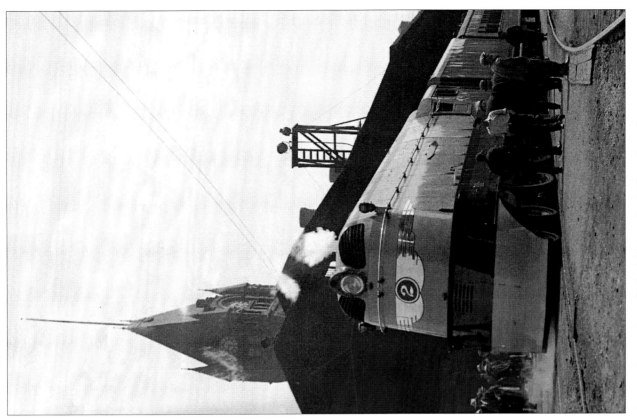

A crowd examines #2 in 1935 at the Milwaukee depot.

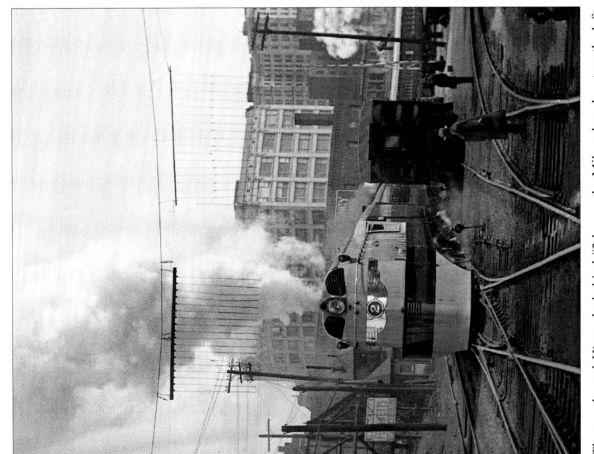

The westbound *Hiawatha* behind #2 leaves the Milwaukee depot on the left-hand main in 1935. It will take the upcoming crossover to switch tracks. A few spectators line the tracks even outside the depot. The one standing inside a switch is definitely not a railroader.

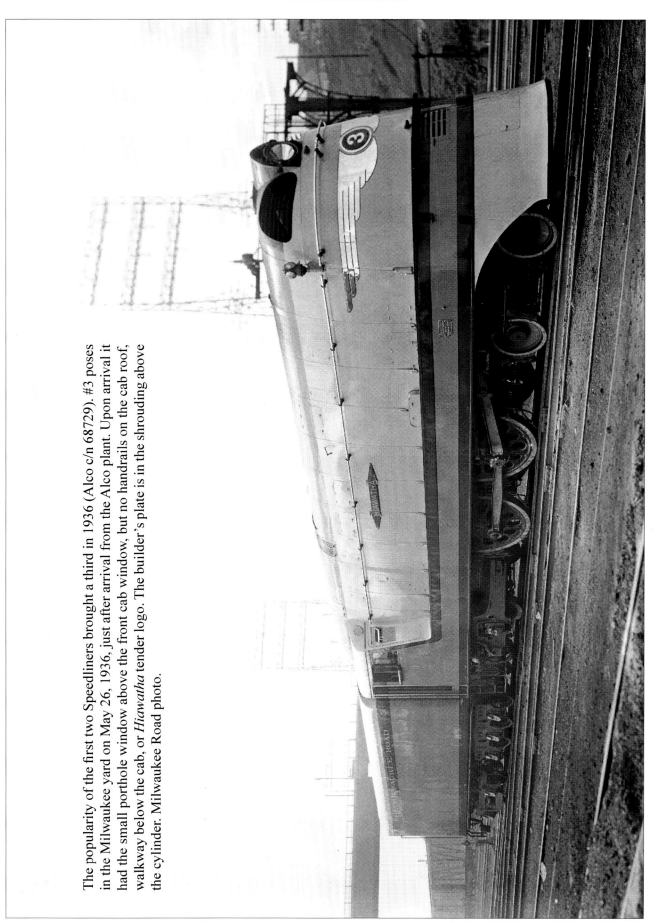

The popularity of the first two Speedliners brought a third in 1936 (Alco c/n 68729). #3 poses in the Milwaukee yard on May 26, 1936, just after arrival from the Alco plant. Upon arrival it had the small porthole window above the front cab window, but no handrails on the cab roof, walkway below the cab, or *Hiawatha* tender logo. The builder's plate is in the shrouding above the cylinder. Milwaukee Road photo.

THE SPEEDLINERS

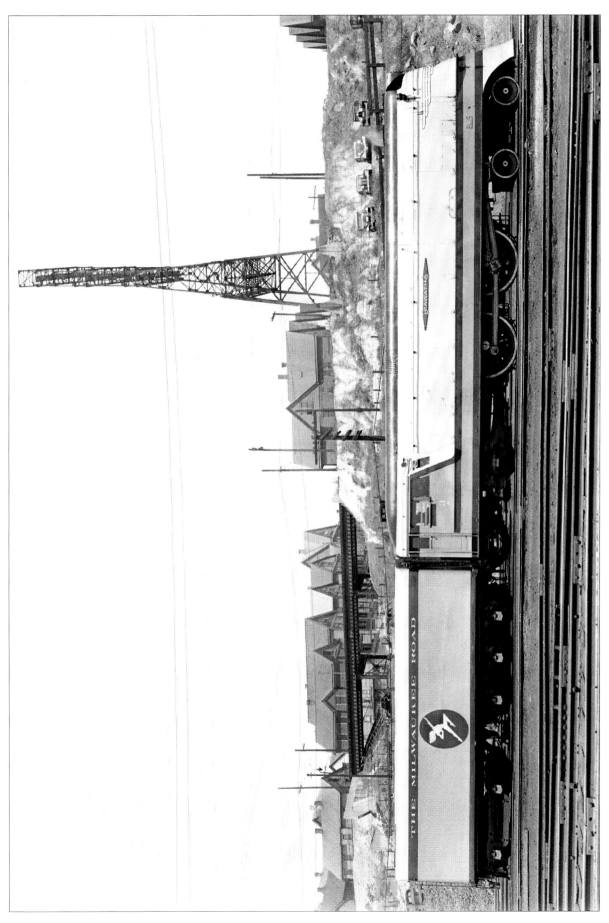

A year later #3 has evolved to add the needed walkway and handrail and the "running Indian" insignia on the tender. The gray colored boiler shrouding looks quite prominent in this photo. Noted industrial designer Otto Kuhler was employed in the art department at the American Locomotive Company (Alco) and suggested the gray color to Milwaukee Road designers, who had created an orange, maroon and brown design for the locomotive.

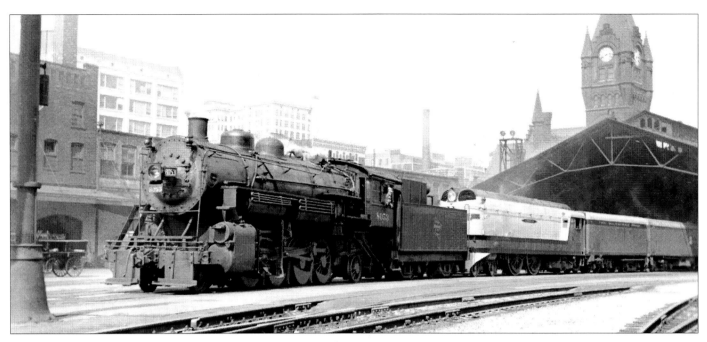

L2 class Mikado #8053 (Alco 1912) acts as a helper for a *Hiawatha* departing the depot westbound. The 2:40 p.m. departure is slightly off schedule, probably because of the Mikado's speed limitations.

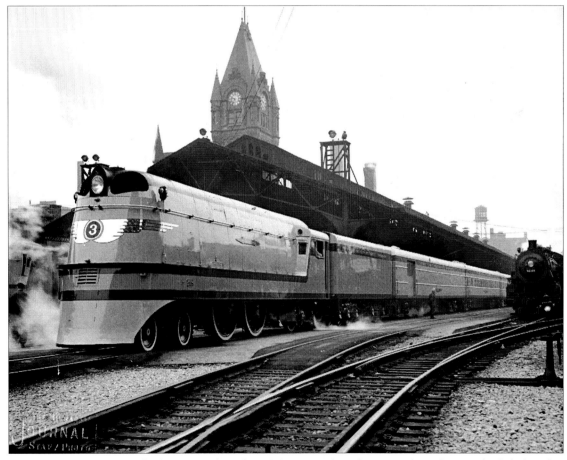

October 7, 1936, sees #3 in steam, but the 10:35 a.m. time is not a time for a scheduled train. *Milwaukee Journal* photo.

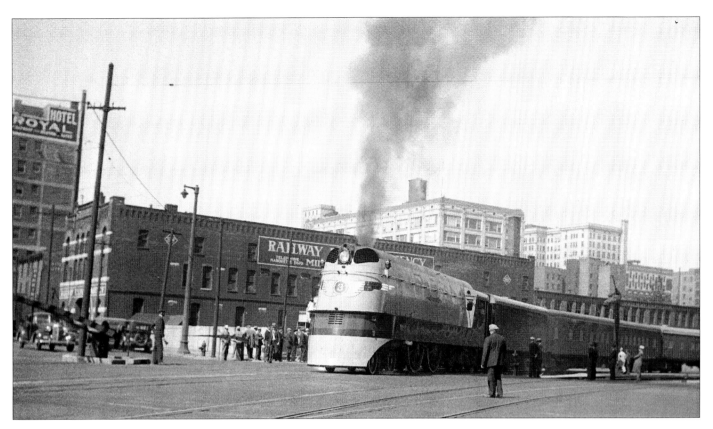

#3 has taken water, completed its station stop, and is just departing It is the main attraction on August 15, 1936.

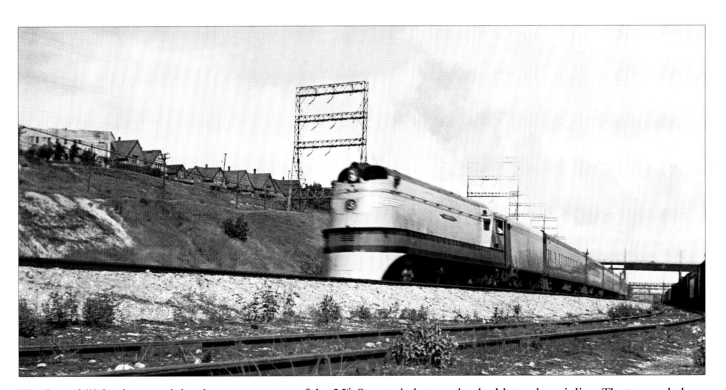

Westbound #3 heels around the shops curve west of the 35th Street viaduct on the double track mainline. The towers belong to The Milwaukee Electric Railway and Light Company, whose right-of-way parallels the Milwaukee Road main line here.

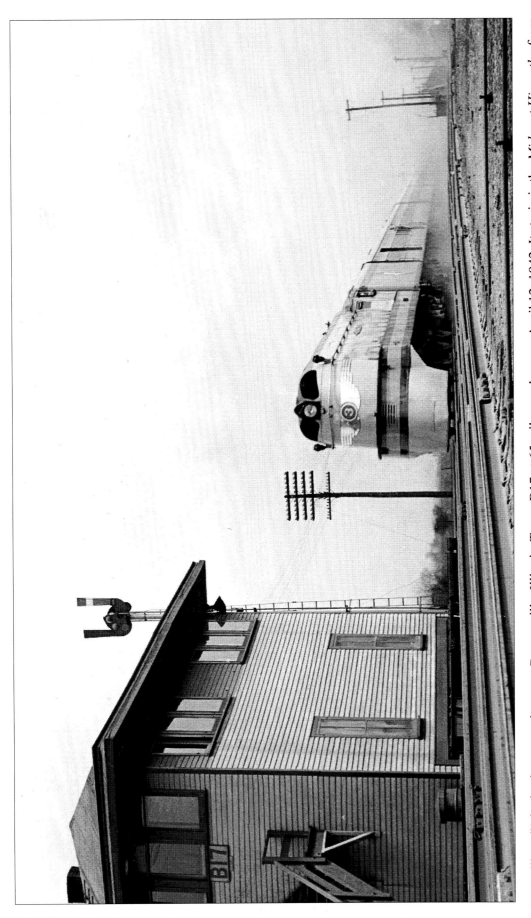

Speedliner #3 looks the part as it passes Bensenville, Illinois, Tower B17 at 65 miles per hour on April 12, 1942. Its train is the *Midwest Hiawatha* from Chicago to Omaha and Sioux Falls, which was inaugurated on December 11, 1940. The train carries a Railway Post Office (RPO) car. Henry J. McCord photo.

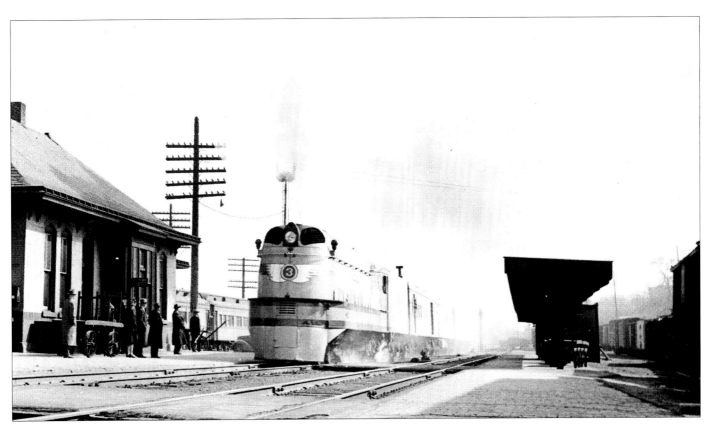

The same #3 on the *Midwest Hi* blasts past the old depot at Elgin, Illinois, in the 1940's. The Atlantics inaugurated the *Midwest Hiawatha* and pulled it until the end of World War II. Commuter cars are in background.

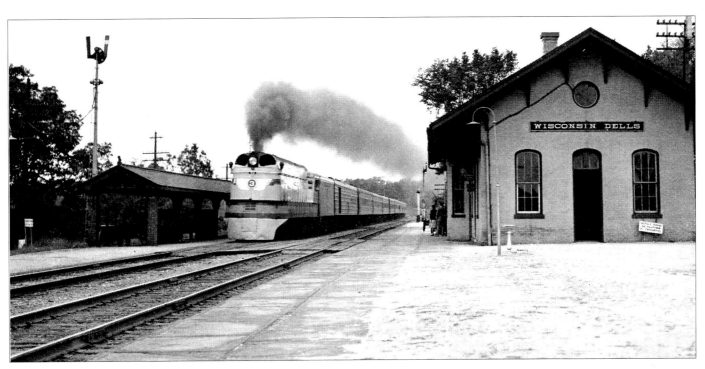

Eastbound #3 on train No. 100 slows to 40 miles per hour through Wisconsin Dells on the *Hiawatha* on September 24, 1941. The original Wisconsin Dells depot was demolished in 1980 by a derailed coal train, but a replica was constructed and today it serves Amtrak.

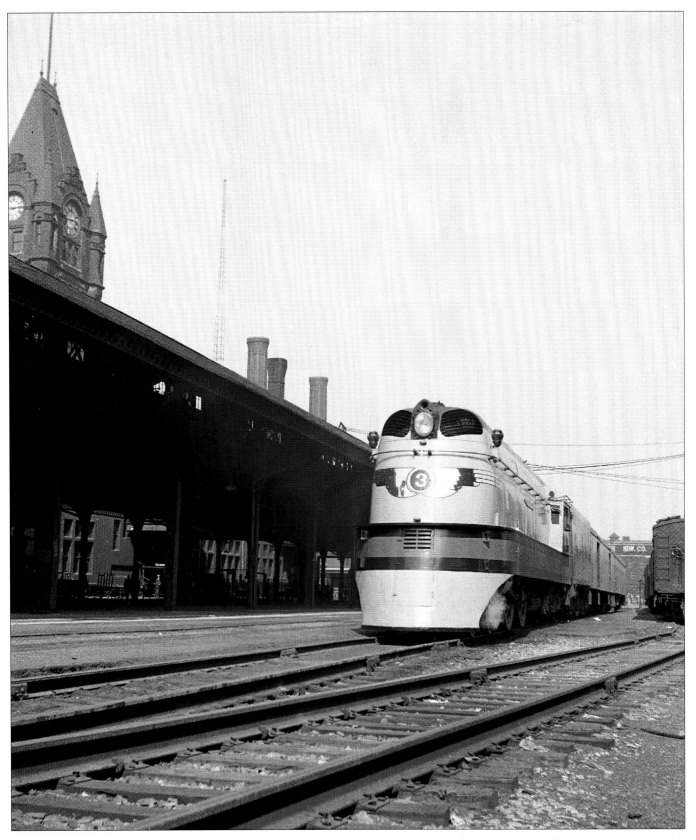
The make-up of #3's train and use of the far platform track outside the trainshed at Milwaukee tell us this is not a regular *Hiawatha* train making its two-minute scheduled station and water stop. #3 was the first of the A's to be retired.

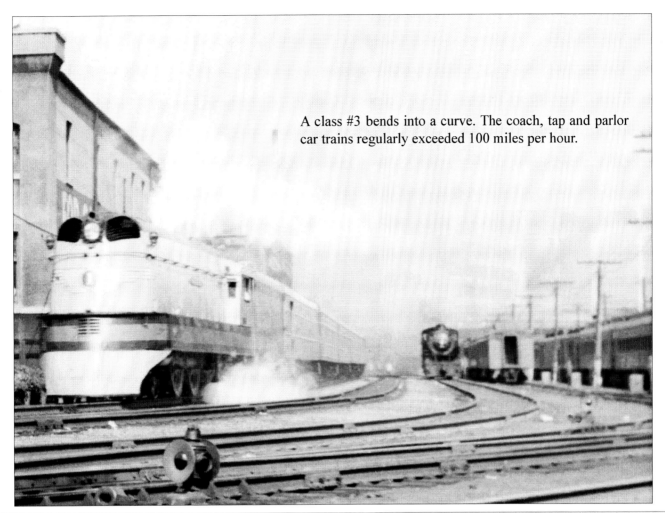

A class #3 bends into a curve. The coach, tap and parlor car trains regularly exceeded 100 miles per hour.

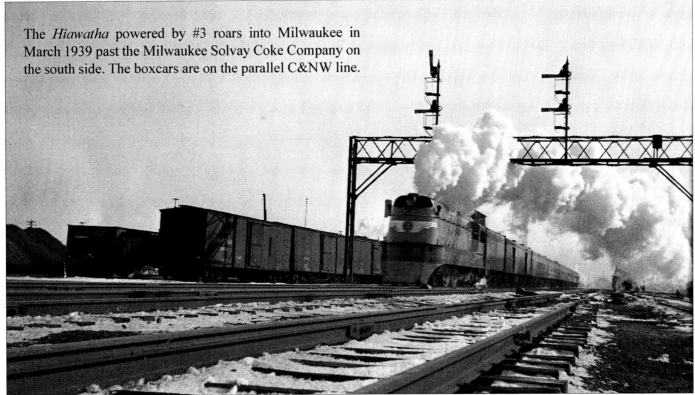

The *Hiawatha* powered by #3 roars into Milwaukee in March 1939 past the Milwaukee Solvay Coke Company on the south side. The boxcars are on the parallel C&NW line.

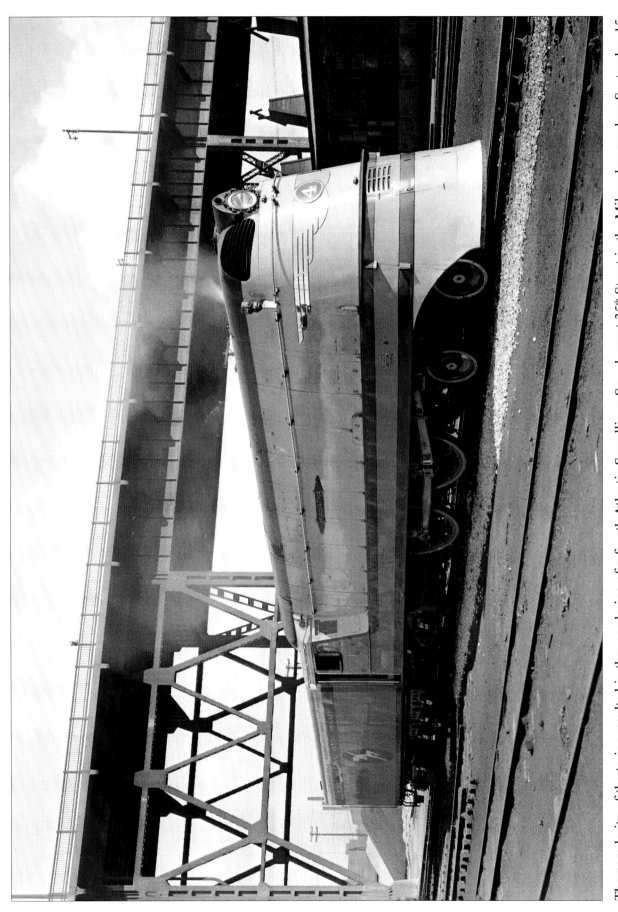

The popularity of the trains resulted in the reordering of a fourth Atlantic Speedliner. Seen here at 35th Street in the Milwaukee yard on September 15, 1937, #4 (Alco c/n 68828) arrived in April with the tender insignia already in place. Milwaukee Road photo.

THE SPEEDLINERS

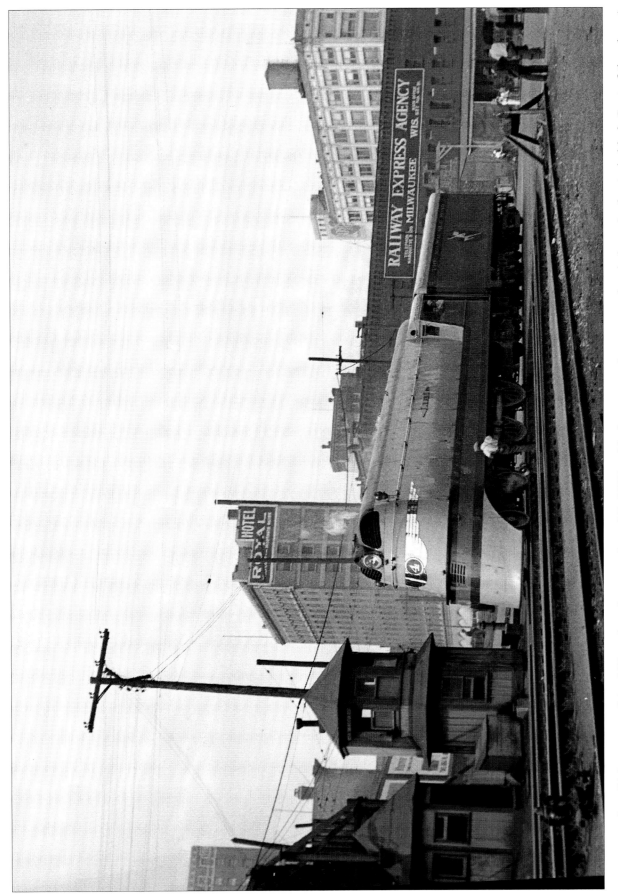

Spectators view #4 just west of the Milwaukee depot on June 27, 1937, with the gateman's tower and switchman's shanty behind. Cost of the class A Speedliners was $85,000 each – all four equaling the cost of a diesel-electric passenger locomotive at the time.

The Speedliners

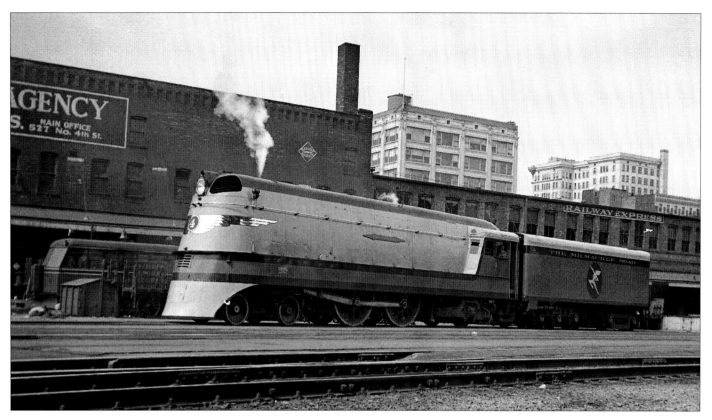

Sun reflects off the nose wings as Roy Campbell caught streamlined #4 alone at the depot platform on June 27, 1937. Behind the locomotive is the Railway Express Company building.

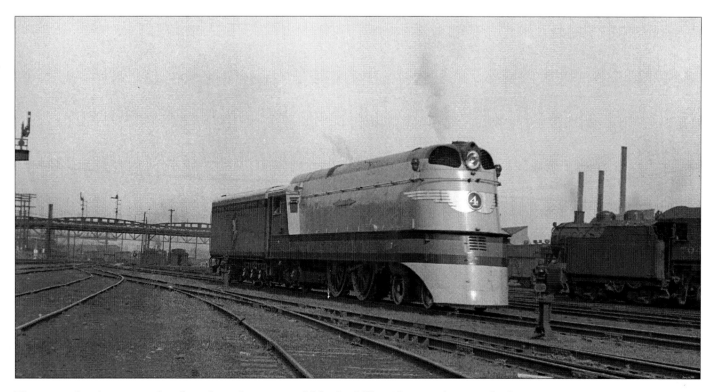

The same day he snapped a gleaming, almost new #4 in the Milwaukee engine terminal.

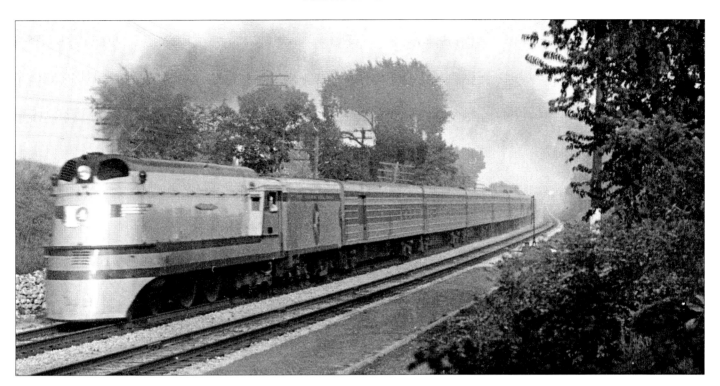

#4 pulls a long train of 1938 *Hiawatha* cars on the double-tracked main line. Careful examination of the tender shows a rounded maroon semi-circle designed to start the maroon stripe that follows through on the side of the 1938 cars. Harvey Uecker photo.

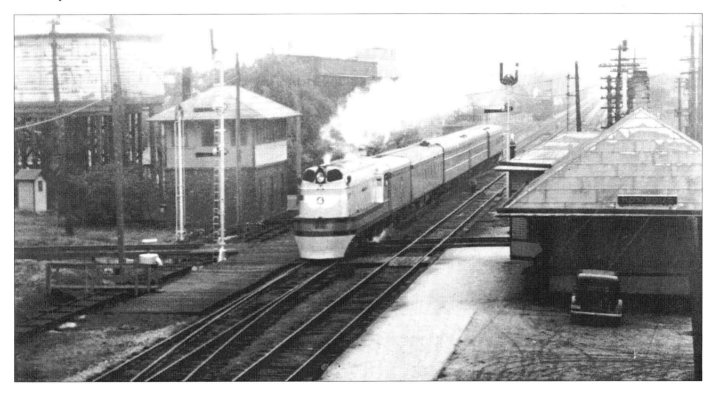

This time with an abbreviated train, #4 slows to 80 miles per hour for the junction with the Elgin, Joliet & Eastern at Rondout, Illinois. The photograph was taken from the right of way of the Chicago, North Shore & Milwaukee, which passed over the steam roads on an embankment and bridge.

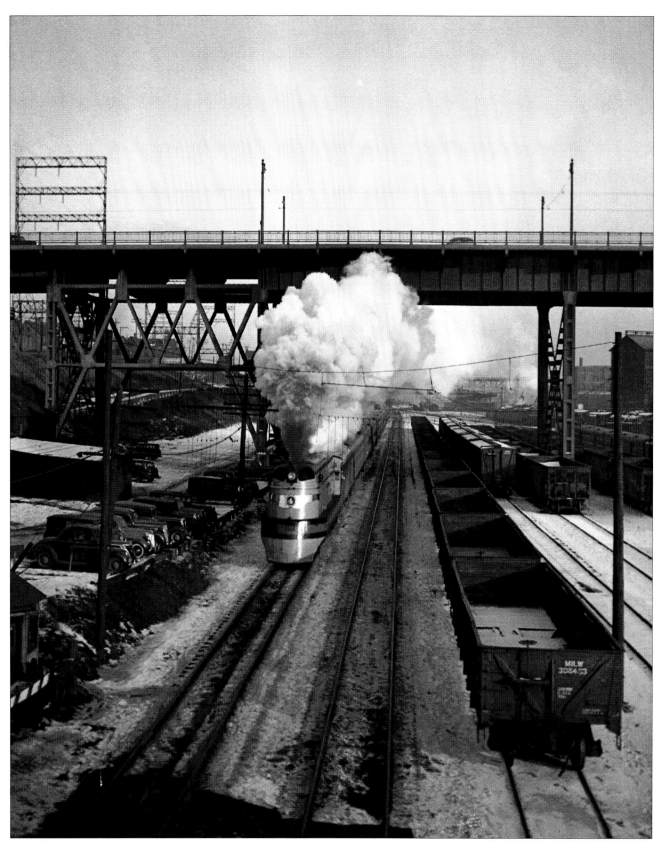

#4 blasts under the viaduct at West Milwaukee in December 1938. A string of empty coal gondolas awaits return to southern Indiana for more locomotive coal. Shops employee parking is at left, with their crossing at the very bottom of the photo.

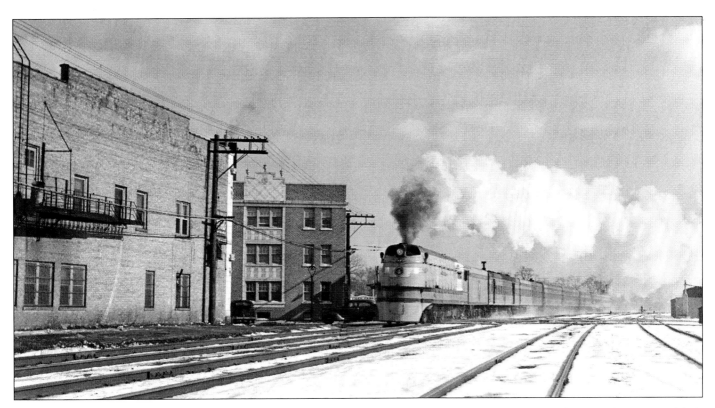

By 1940 the Twin Cities-Chicago trains were so successful that they required heavier power, and new trains were added. The streamlined Atlantics were transferred to the new *Midwest Hiawatha* from Chicago across Northern Illinois and Iowa to Omaha, Sioux City, and Sioux Falls, South Dakota. The *Midwest Hi* approaches behind #4 at Elmwood Park on February 9, 1941.

And disappears in the distance, with a Beaver Tail observation car showing the markers. The original cars' rear windows have been modified with wider expanse of glass to capitalize on the receding views. When the train split at Manilla, Iowa, the parlor observation cars went through to Sioux Falls on the South Dakota section, and the A class locomotives continued with the train to Omaha.

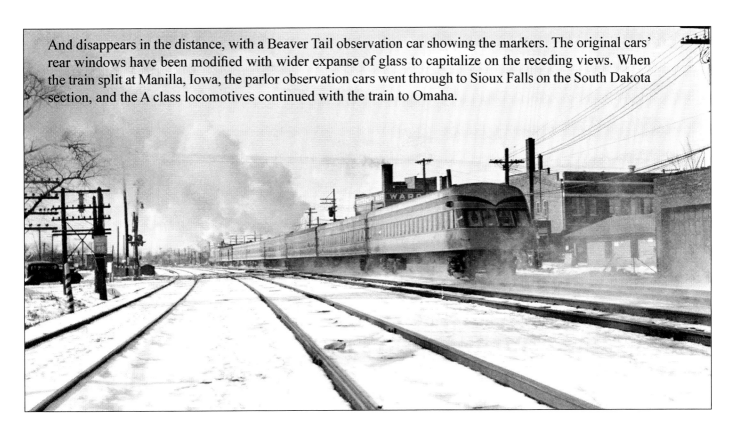

F7 Class Hudsons

The success of the new *Hiawathas* resulted in longer trains, finally reaching the point where larger Speedliner power was necessary. The Milwaukee already had positive experience with its F6 Hudsons, one of which, #6402, set a speed record between Chicago and Milwaukee while demonstrating the viability of the high-speed trains. Six completely new colorful shrouded 4-6-4's (#100-105) were outshopped by Alco in 1938. They initially took over the *Hiawathas* when their consist exceeded nine cars, and finally were permanently assigned to these trains. Both *Morning Hiawathas* and *Afternoon Hiawathas* were introduced at the beginning of 1939. The F7's were also used as needed on other trains such as the *Pioneer Limited* and *Olympian*. Dieselization of the *Hiawathas* began in 1941, but the press of wartime traffic delayed its full implementation until 1946.

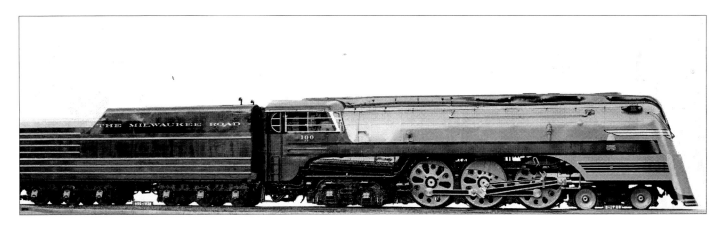

F7 class #100 in its initial portrait. The paint scheme is much more complex than that of the A class. The type of photographic film used makes the orange paint look much darker than it is. Alco builder's photo.

AMERICAN LOCOMOTIVE COMPANY
NEW YORK

Class. 464 S 415
Road Number, 100
BUILT FOR THE CHICAGO, MILWAUKEE, ST. PAUL & PACIFIC.

GAUGE OF TRACK	CYLINDERS		DRIVING WHEEL DIAMETER	BOILER		FIRE BOX		TUBES		
	Diam.	Stroke		Inside Dia.	Pressure	Length	Width	Number	Diameter	Length
4'-8½"	23½"	30"	84"	82½"	300 lbs	144½"	96 3/16"	60 / 164	2¼" / 3¾"	19'-0"

WHEEL BASE			WEIGHT IN WORKING ORDER—POUNDS				
Driving	Engine	Engine & Tender	Leading	Driving	Trailing	Engine	Tender
14'-8"	42'-4"	89'-10"	82500	216000	116500	415000	375000

FUEL		EVAPORATING SURFACES, SQUARE FT.					SUPERHEATING SURFACE SQUARE FT.	GRATE AREA SQ. FT.	MAXIMUM TRACTIVE POWER	FACTOR OF ADHESION	
Kind		Tubes	Flues	Fire Box	Arch Tubes	Syphons	Total				
Soft Coal		667	3041	348	19	91	4166	1695	96.5	50300 lbs.	4.29

Tender Type, 12-Wheeled Capacity, Water, 20000 Gals. Fuel, 25 Tons

Builder's data for #100-105 (c/n 69064-69069).

The Speedliners

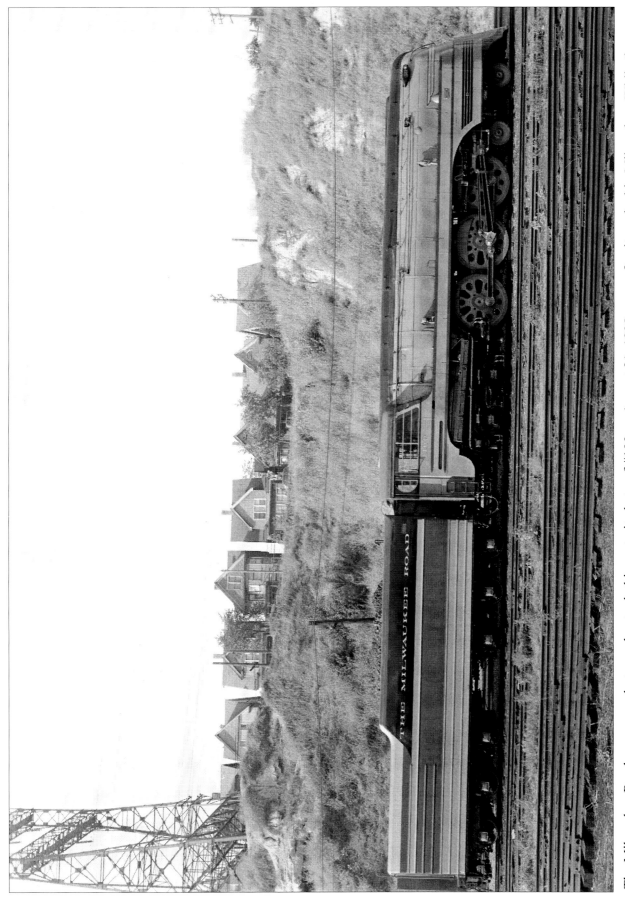

The Milwaukee Road company photographer took this portrait photo of #100 on August 31, 1938, soon after its arrival in Milwaukee. While the same general lines of the streamlined A class was retained, the shrouding on the new Hudsons did not extend over the drivers for weight reasons. Milwaukee Road photo.

The Speedliners

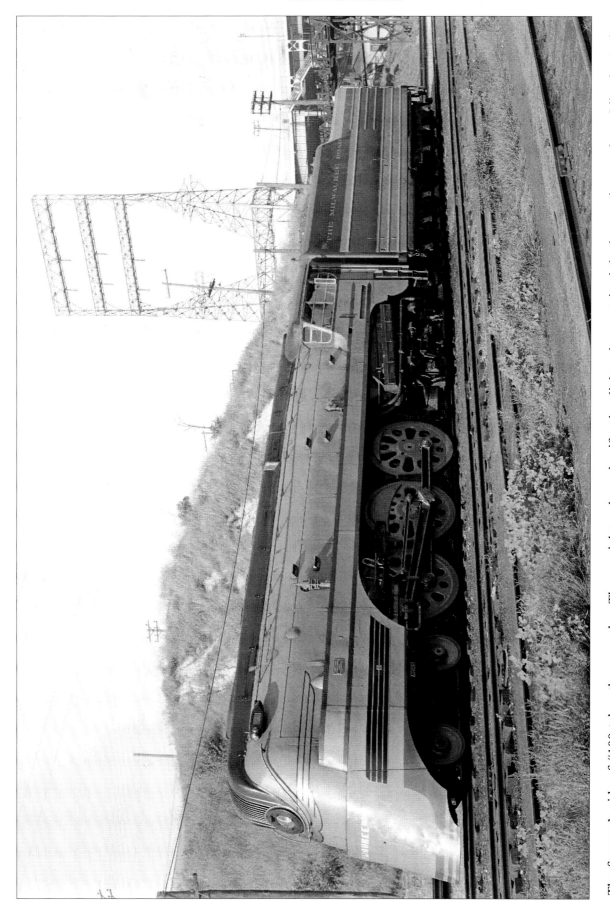

The fireman's side of #100 taken the same day. The special teardrop classification lights also contained the locomotive numbers. Like the A class locomotives, the F7's had 84-inch drivers and 300 psi maximum boiler pressure. They exerted 50,300 pounds tractive effort (TE). Milwaukee Road photo.

The Speedliners

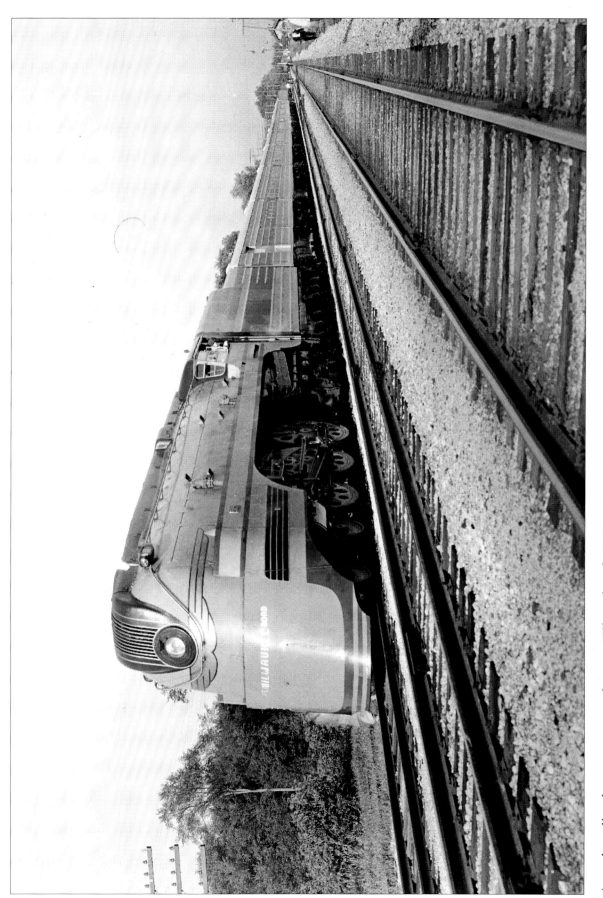

A week earlier the company ran the new "Hiawatha of 1939" extra to Brookfield for publicity photos. While the same colors of gray and orange accented with maroon and black were kept, Alco industrial designer Otto Kuhler redesigned the color scheme to carry the maroon tender stripe the length of the train. The horizontal ribs similarly extended from the tender along the cars. Milwaukee Road photo.

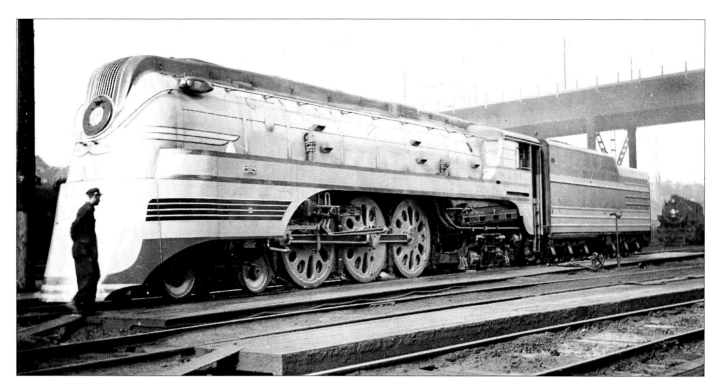

A vertical grille extended from the headlight up into the black cowling. The front "wings" were retained, but no longer featured the locomotive's number. The Alco builder's plate is in the orange running board stripe above the lead truck. The new paint scheme does not include a *Hiawatha* insignia.

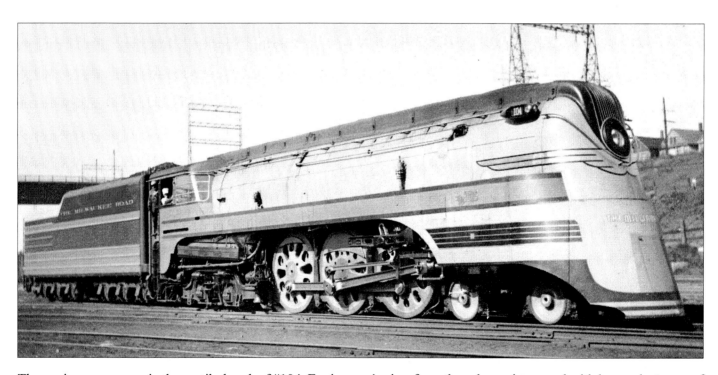

The engine crew poses in the vestibule cab of #104. Enginemen's view from the cab was improved with larger shatterproof glass windows. The Walschaert valve gear and Boxpok drivers are visible on the F7's.

The Speedliners

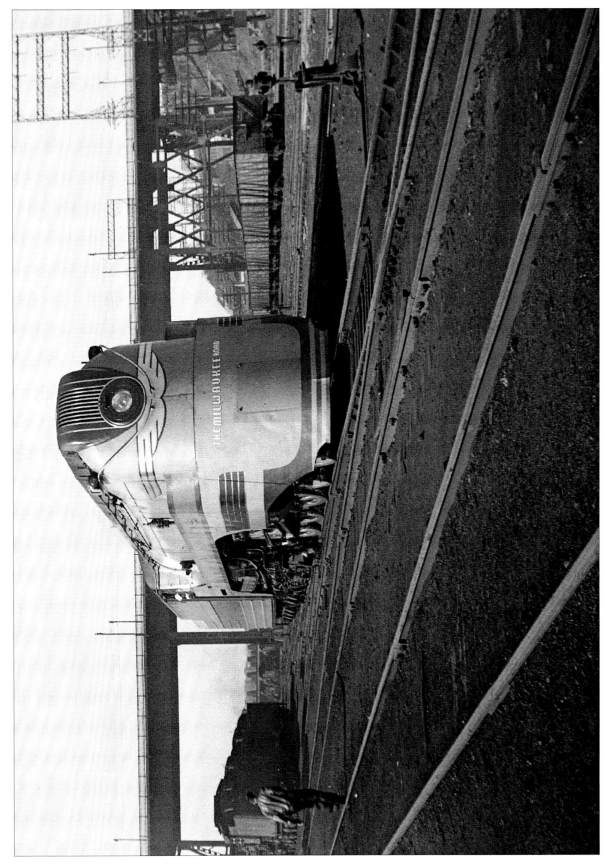

Campbell visited a new #104 in the Milwaukee yard on October 16, 1938. The roundhouse is visible in the background.

The Speedliners

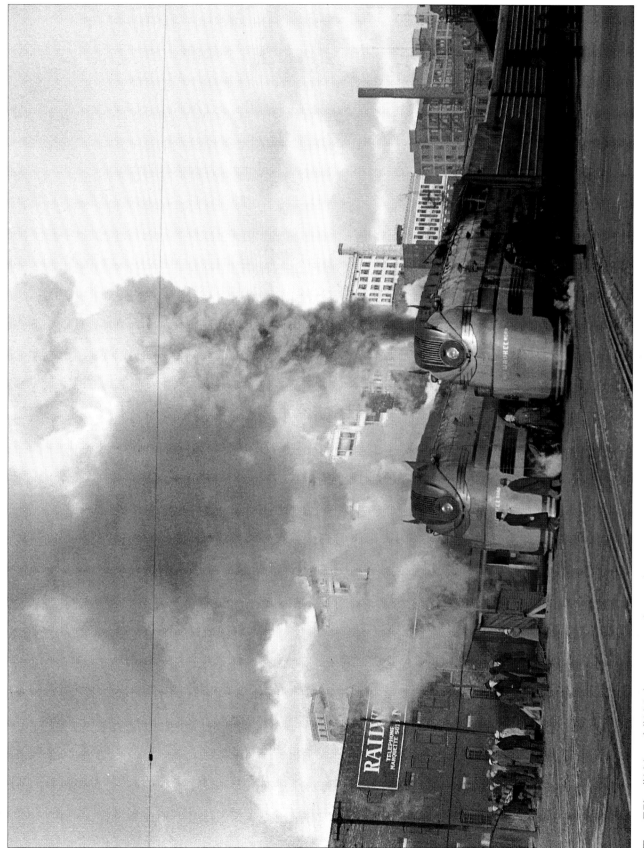

Two F7's, #101 and #105 drew a crowd at Union Station in Milwaukee in December 1939. Both carry green flags signifying additional sections followed, probably filled with holiday traffic.

The Speedliners

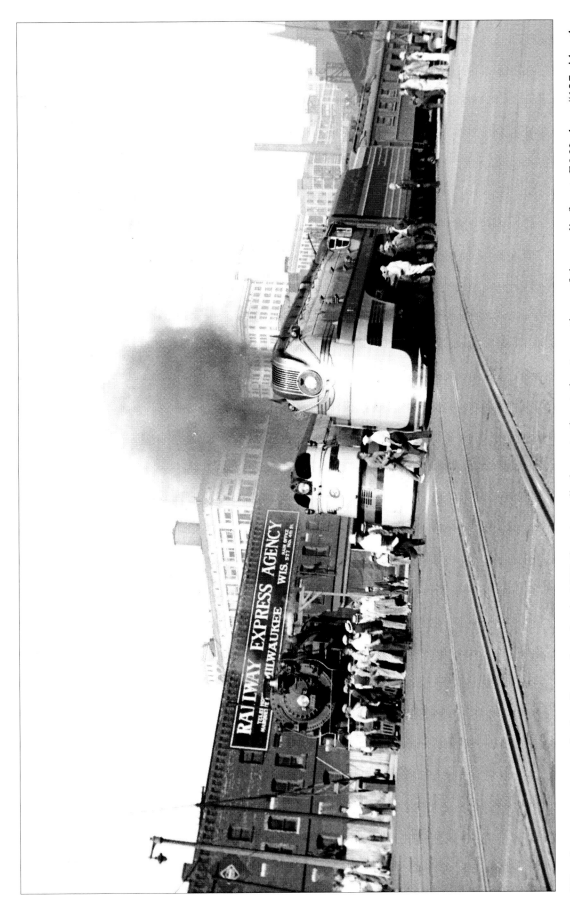

What better way to spend a hot September day in 1938 than to walk down to the station to see three of the road's finest. F6 Hudson #127 rides the station turntable, A class #3 awaits departure, and new F7 #100 carrying green flags and pulling a conventional train gets lots of running gear attention.

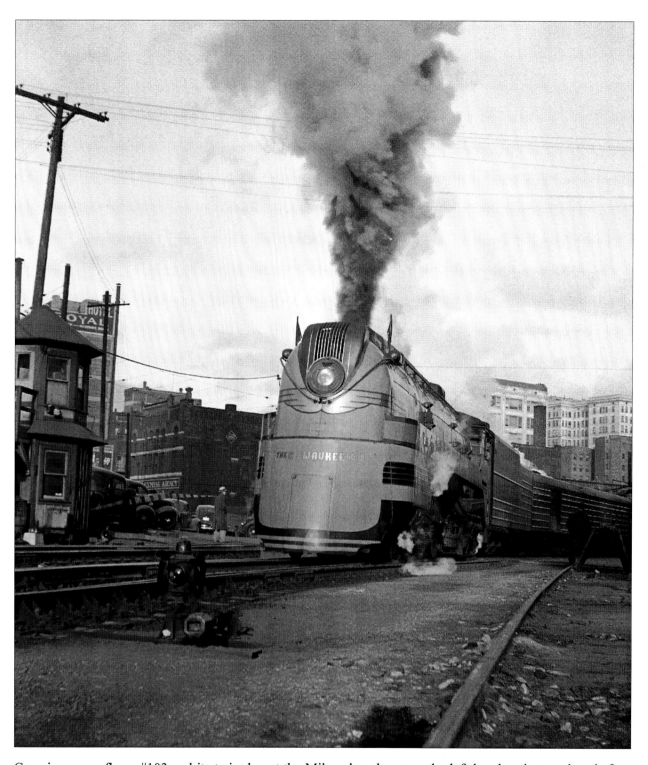

Carrying green flags, #103 and its train depart the Milwaukee depot on the left-hand main two days before Christmas 1938. The 1938 cars (publicly called the "train of 1939") were constructed of Cor-Ten steel and aluminum alloys, weighing 41-43% less than standard heavyweight cars. They had retractable steps and only one vestibule per car, and the underbody equipment was encased to reduce wind resistance and lower the center of gravity. The trucks, designed by Milwaukee Road Chief Mechanical Officer Karl Nystrom, are still considered the best riding passenger trucks ever.

The Speedliners

#104 is on the service track at Milwaukee on October 16, 1938, topping off its water, sand and coal before heading into the roundhouse. Where the A's had been oil burners, the F7 Hudsons burned coal, a change which required installation of a "rapid coaler" at New Lisbon to refuel during the brief stop there. A Standard stoker fed the firebox. The tenders carried 20,000 gallons of water and 25 tons of coal.

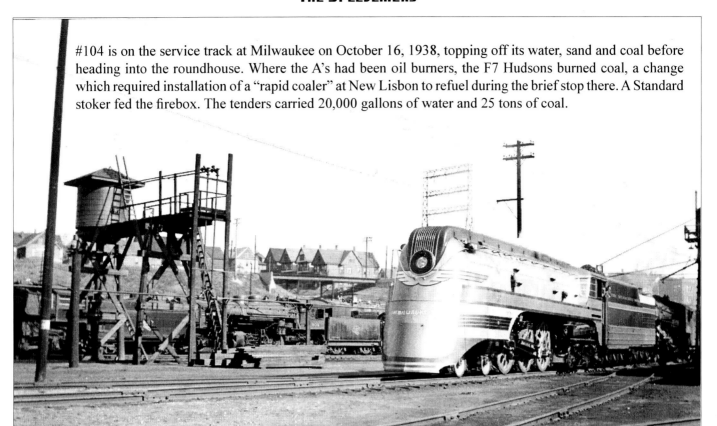

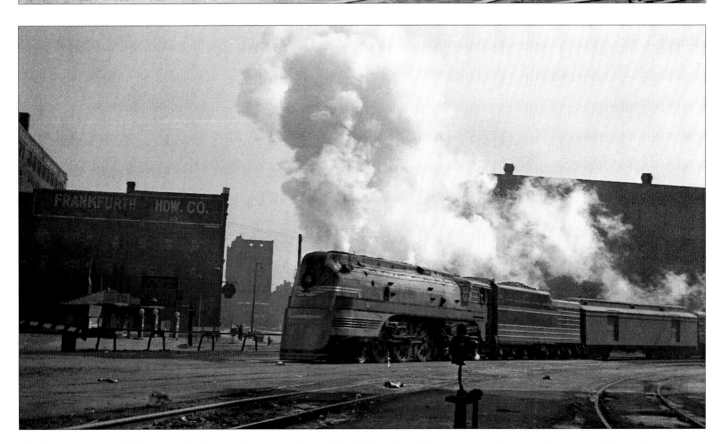

#103 curves into Milwaukee's Union Depot on May 17, 1941. The F7's were used not only on the *Hiawathas,* but as power was needed on other passenger trains.

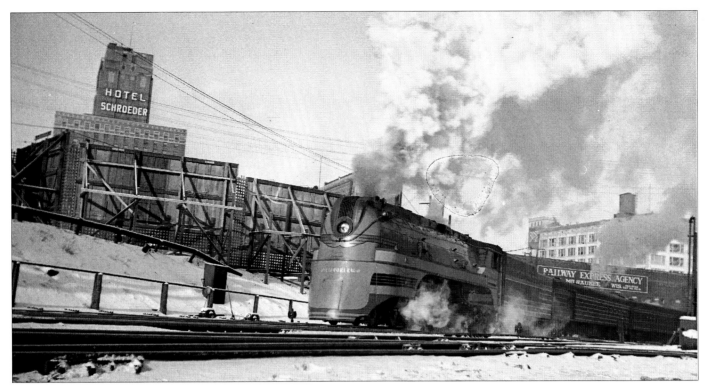
#101 leaves the Milwaukee depot with the new *Hiawatha* cars in September 1938. All wheels had roller bearings.

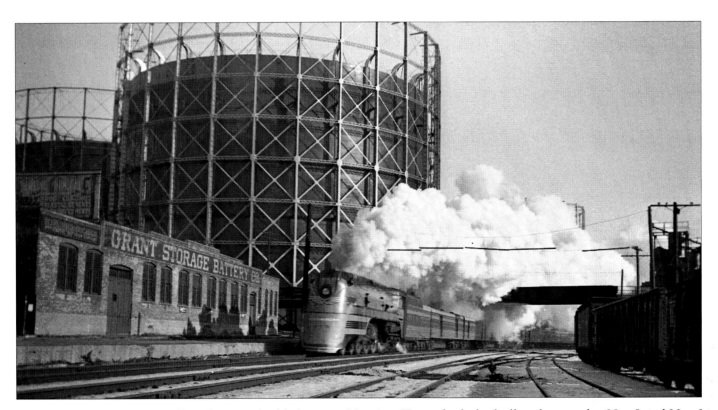
On January 21, 1939, the Milwaukee Road added a new *Morning Hiawatha* in both directions, trains No. 5 and No. 6 (formerly *The Day Express*.) The original *Hiawatha* now became the *Afternoon Hiawatha*. #100 and the *Afternoon Hi* are already at speed passing the gas holders west of downtown in March 1939.

An F7 and train blast under the 35th Street Viaduct. The horizontal ribs, eventually a Milwaukee Road trademark, flow back from the tender the length of the train. The upper grille houses a Typhoon air horn.

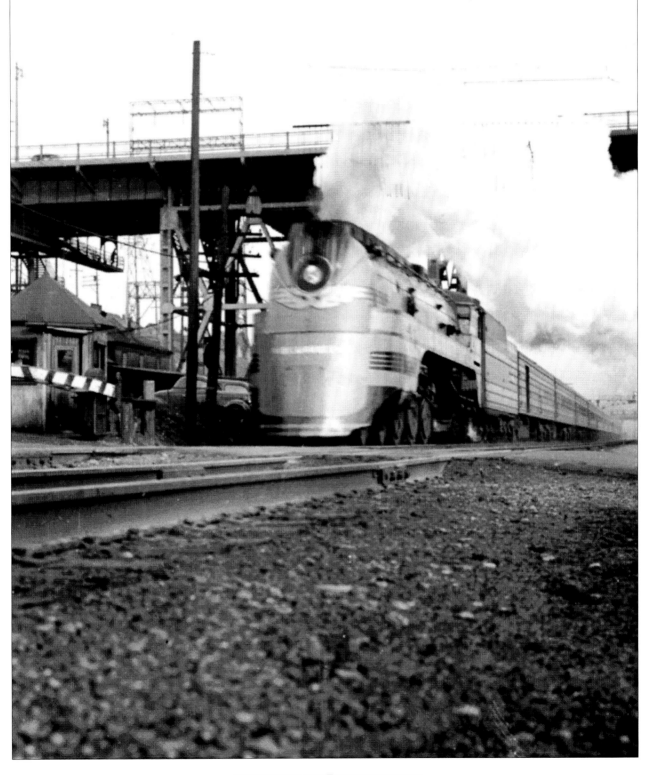

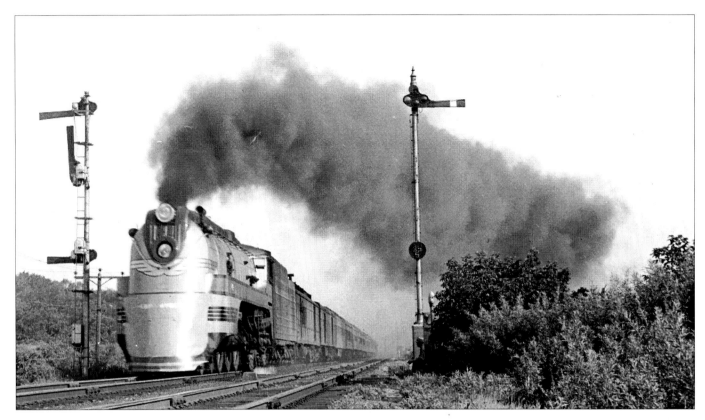

#105 handles the *Arrow* one mile east of Elgin, Illinois. The installation of a Mars light required relocation of the air horn outside the grille. The train consists of both streamlined and conventional cars.

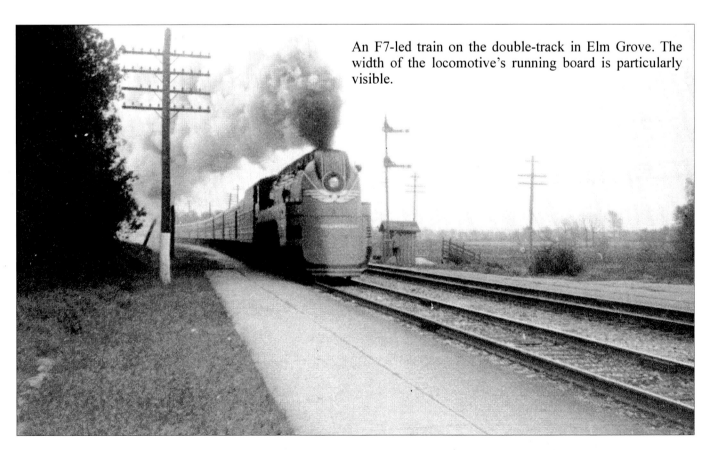

An F7-led train on the double-track in Elm Grove. The width of the locomotive's running board is particularly visible.

THE SPEEDLINERS

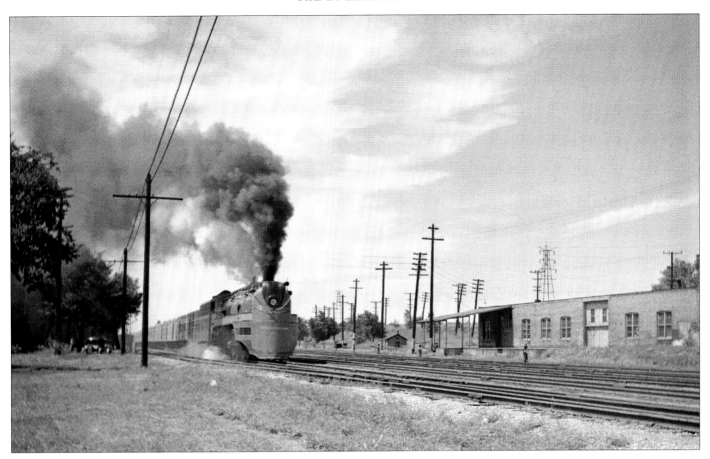

Campbell caught #101 leading the *Afternoon Hiawatha* eastbound out of Portage on July 19, 1941.

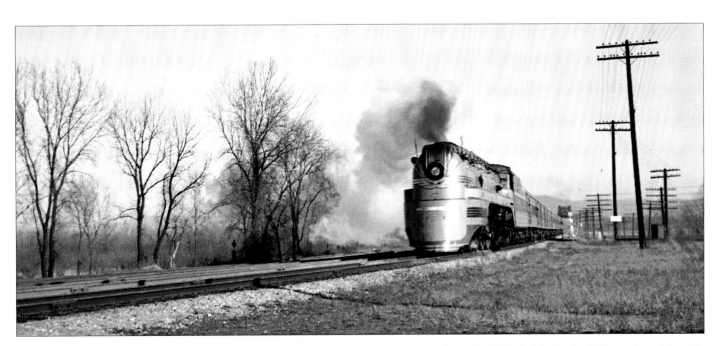

The *Hiawatha* pulled by almost-new #104 approaches LaCrosse on November 15, 1938. Initially the F7's replaced the A's when train length exceeded 9 cars. The morning and afternoon trains are still two months away.

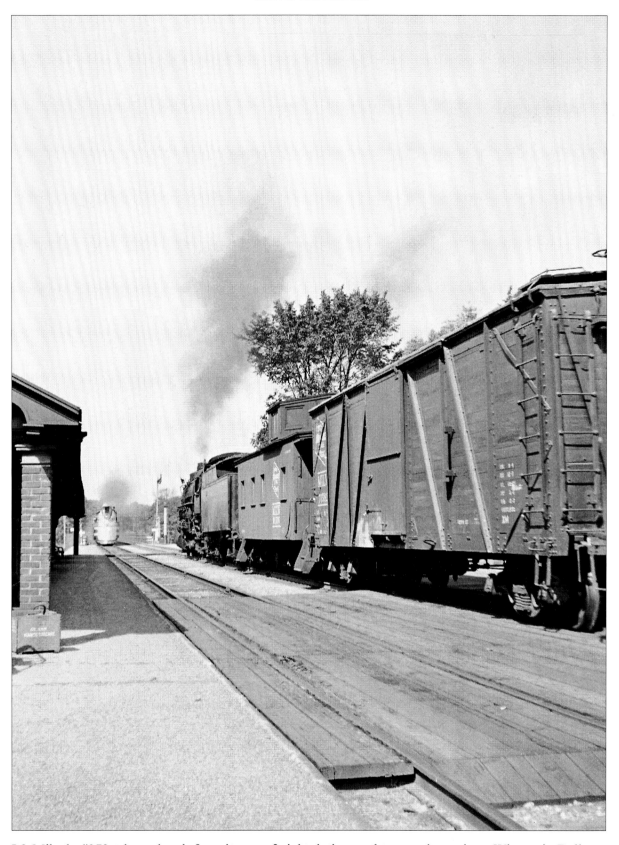

L3 Mikado #373 takes a break from its way freight duties on the opposite main at Wisconsin Dells on October 3, 1940, for the passing of an F7-led *Hiawatha*.

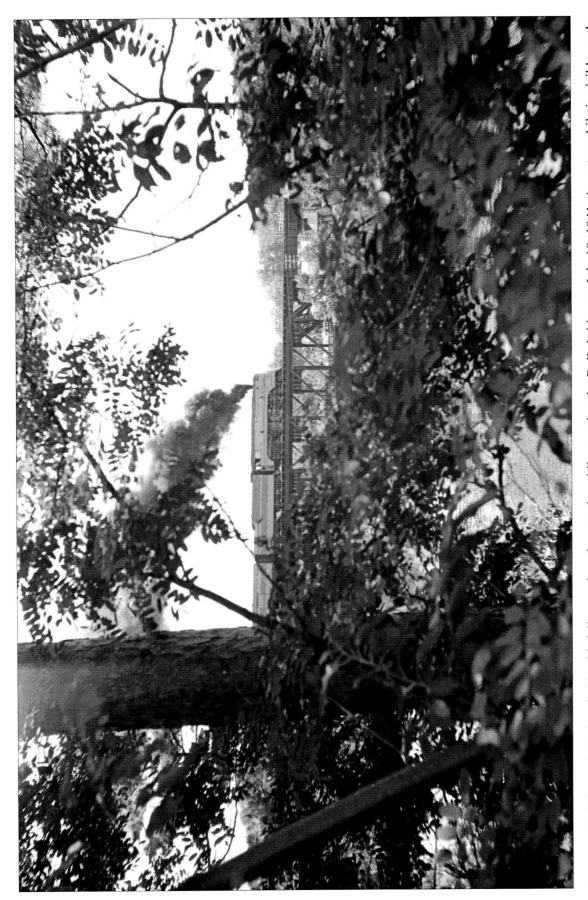

Roy Campbell framed F7 class #103 with foliage as it makes smoke while crossing the Dells bridge on July 19, 1941. An automobile is visible on the lower level of the bridge.

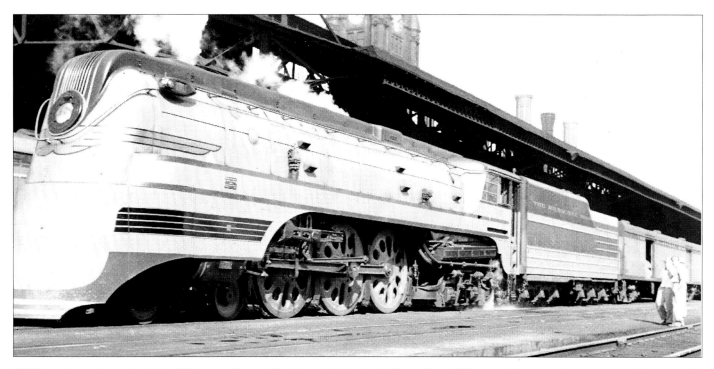

#100 and westbound train hold the track outside the trainshed at Milwaukee. This track does not have a standpipe, so the locomotive is not taking water during the stop.

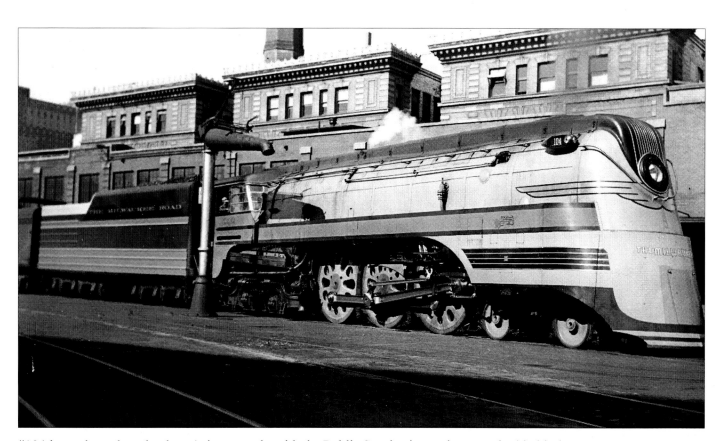

#104 is eastbound on the depot's inner track, with the Public Service interurban terminal behind.

The Speedliners

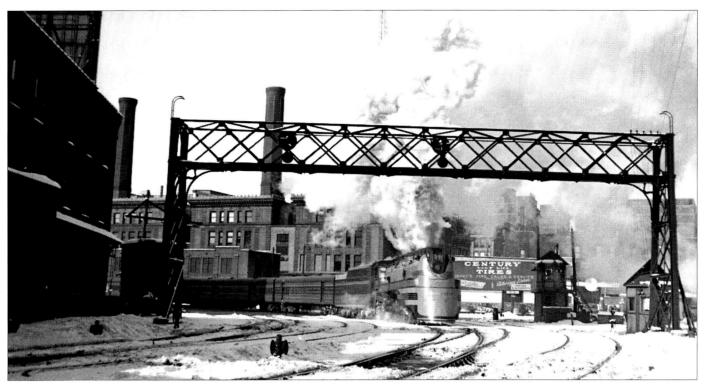

The signal bridge at the curve east of the depot was frequently used as photo framing. Roy Campbell caught #100 there on a snowy February 20, 1940.

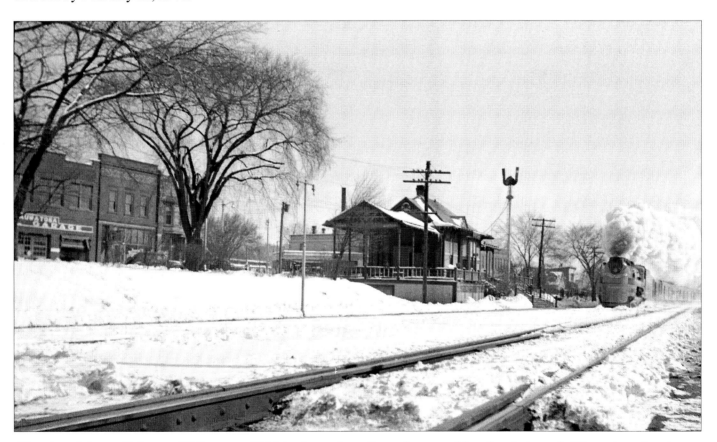

Five days later on February 25 the same #100 is at speed westbound approaching the photogenic Wauwatosa depot.

The Speedliners

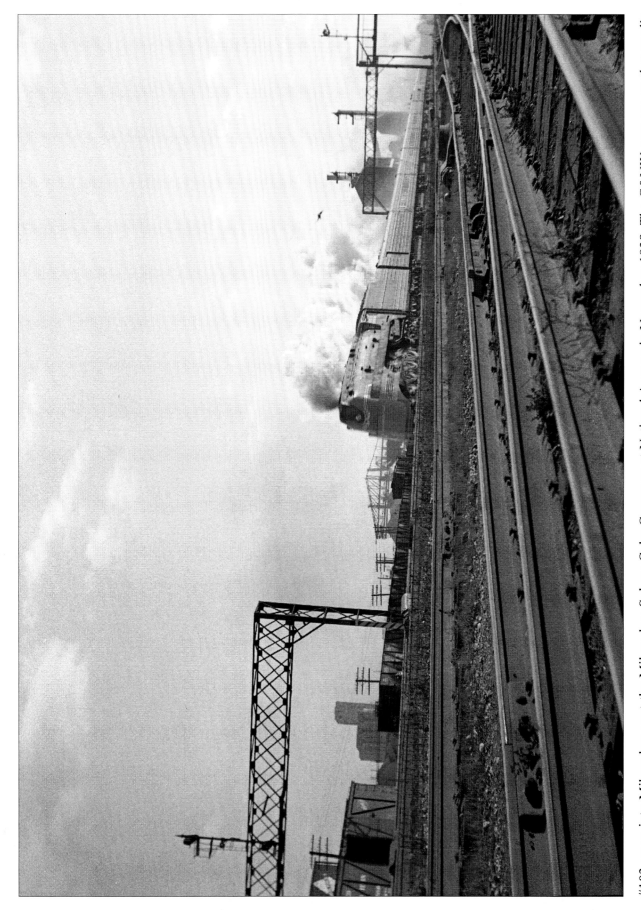

#103 races into Milwaukee past the Milwaukee Solvay Coke Company at National Avenue in November 1938. The C&NW cars are on that road's adjacent tracks.

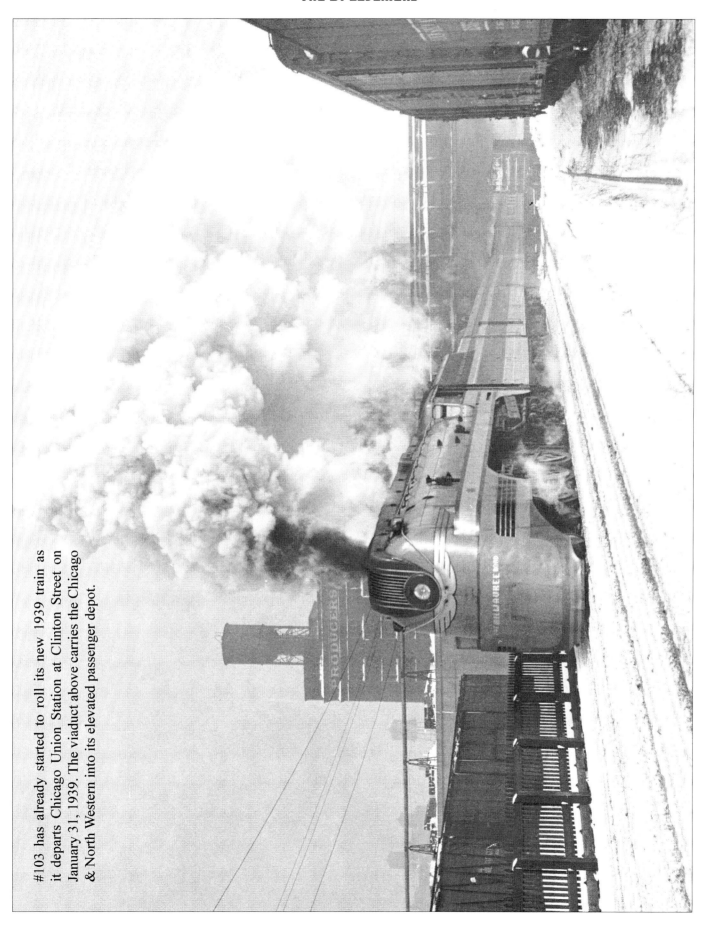

#103 has already started to roll its new 1939 train as it departs Chicago Union Station at Clinton Street on January 31, 1939. The viaduct above carries the Chicago & North Western into its elevated passenger depot.

The Speedliners

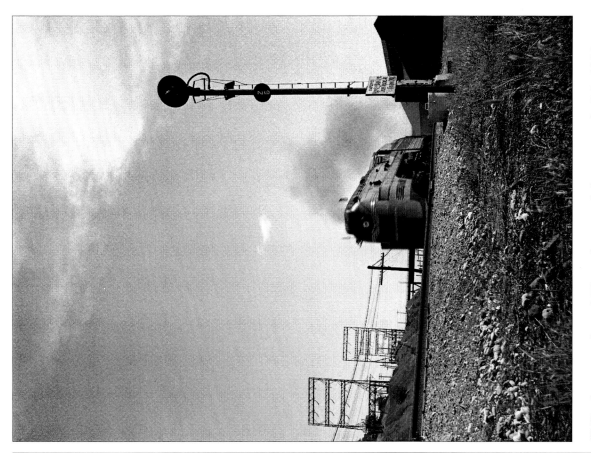

#102 takes a westbound *Hiawatha* around shops curve in July 1939.

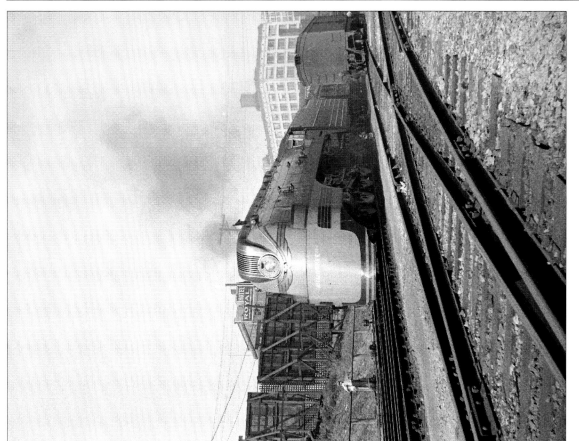

A new #101 carries green flags as it starts through the crossover west of the Milwaukee depot in September 1938.

The Speedliners

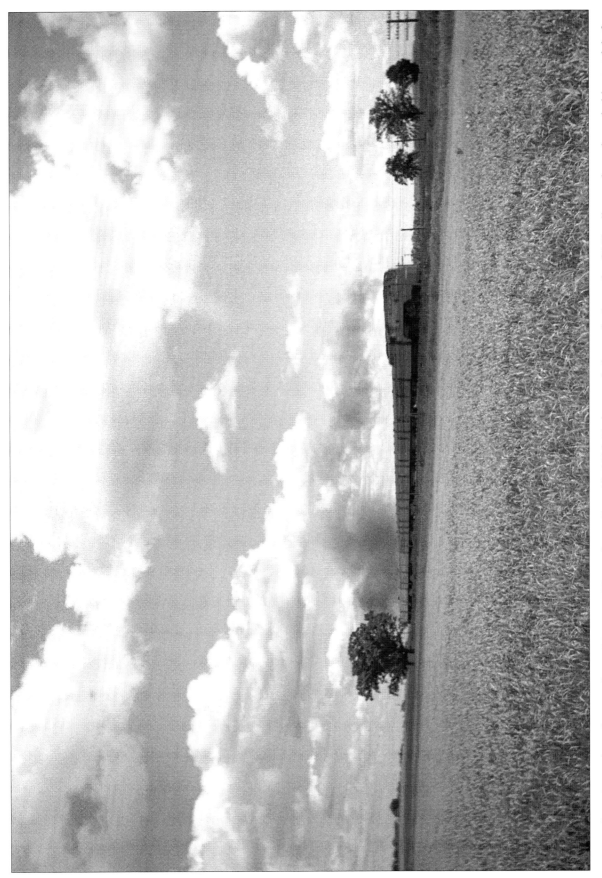

F7 class #100 is westbound at speed near Mauston, Wisconsin, on June 15, 1939. Trains regularly reached speeds of 100 miles per hour through this stretch before applying brakes for the New Lisbon stop for Valley Line connections.

G Class Ten-Wheelers

Arguably the most obscure of the Speedliners were the two shrouded ten-wheelers on the Valley Line, #10 and #11, upgraded with shrouding from two standard locomotives in 1936 to pull the *North Woods Hiawatha* from their New Lisbon connection with the main line trains. While their speeds were relatively pedestrian on the Valley Line's light trackage, they looked fast and allowed passengers to enjoy the luxurious accommodations they experienced on the main line trains. As these trains also became longer, double-heading and finally shrouded Pacifics became necessary. The Valley Line was dieselized in 1947 and the two ten-wheelers were de-shrouded and finished their lives in Chicago suburban service.

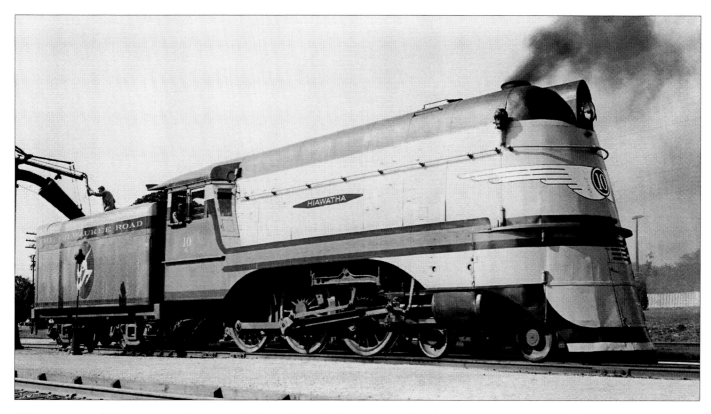

#10 was one of the two G6 class ten-wheelers shrouded and painted to match mainline trains to pull the *North Woods Hiawatha* on the Valley Line. Re-classed G, #10 is at the New Lisbon platform with a full load of coal (12 tons) and taking on water (8500 gallons) in preparation for its run to Wausau, where the train would change engines. #10 was hand-fired but like its mainline streamlined cousins, had air horns.

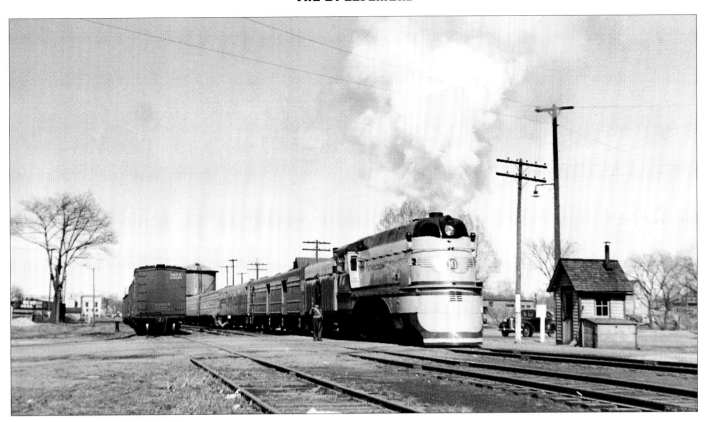

Train No. 200, the eastbound *North Woods Hiawatha*, gets underway from Wisconsin Rapids on April 12, 1939. In the 1930's, Wisconsin Rapids citizens drove to Adams and caught the C&NW's *400* for fast travel to Milwaukee and Chicago, but the inauguration of this train recaptured this business for the Milwaukee Road.

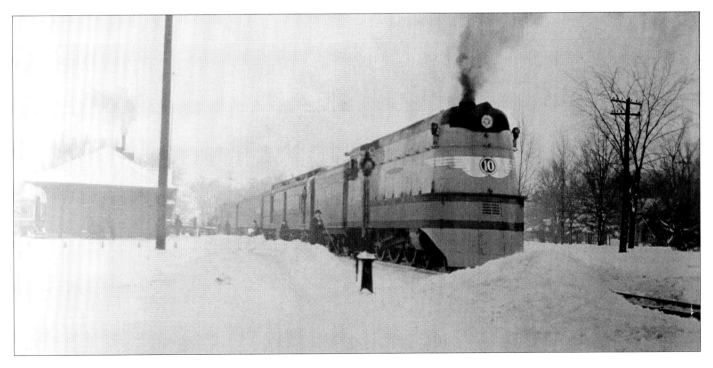

Only months after inauguration of the new train, #10 waits with its blower on at the Wausau depot in a snowstorm on January 8, 1937, on train No. 200. *Hiawatha* coaches and a parlor car follow a standard RPO/express car. This photo was taken by a company photographer the same day as he took the photo on page 15, indicating that he had ridden the train that day. Milwaukee Road photo by Harvey Uecker.

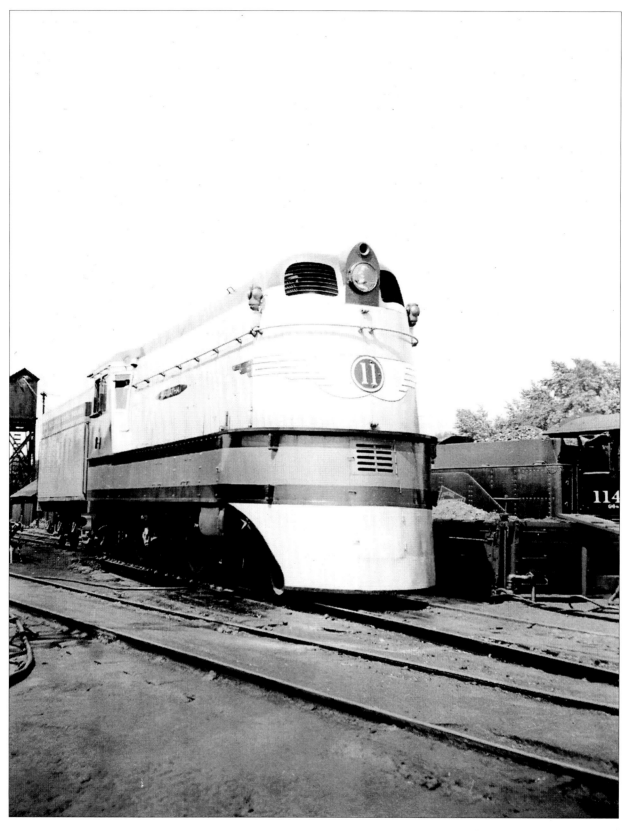

G class #11 is over the ash pit in the Wausau engine terminal. It bears the early full skirting and paint scheme without the tender insignia; the skirt was later cut away for access to the locomotive's mechanism.

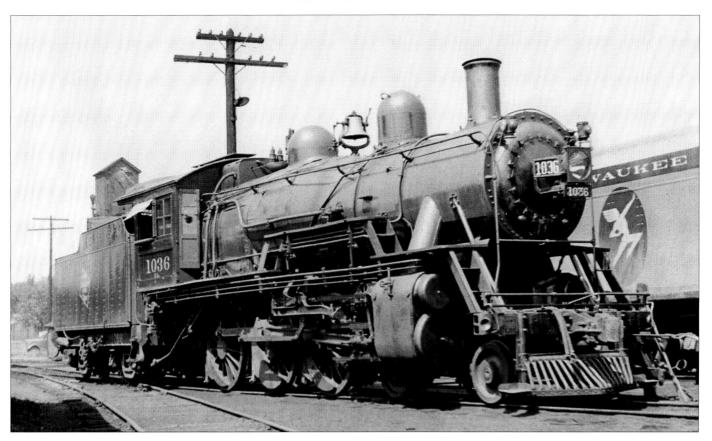

G8a class 4-6-0 #1036 sits with its stack covered in the Wausau engine terminal, with Hiawatha himself peeking from the flank of a tender behind. A regular Valley Line locomotive, #1036 was best known for its boiler explosion three miles south of Necedah on February 4, 1940, that killed its three-man crew.

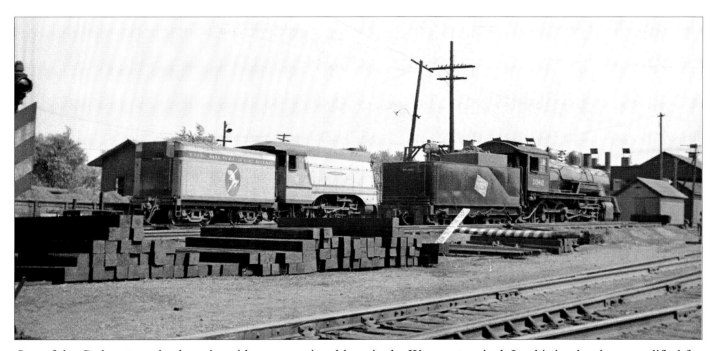

One of the G class ten-wheelers sits with a conventional loco in the Wausau terminal. Its skirting has been modified for easier access.

THE SPEEDLINERS

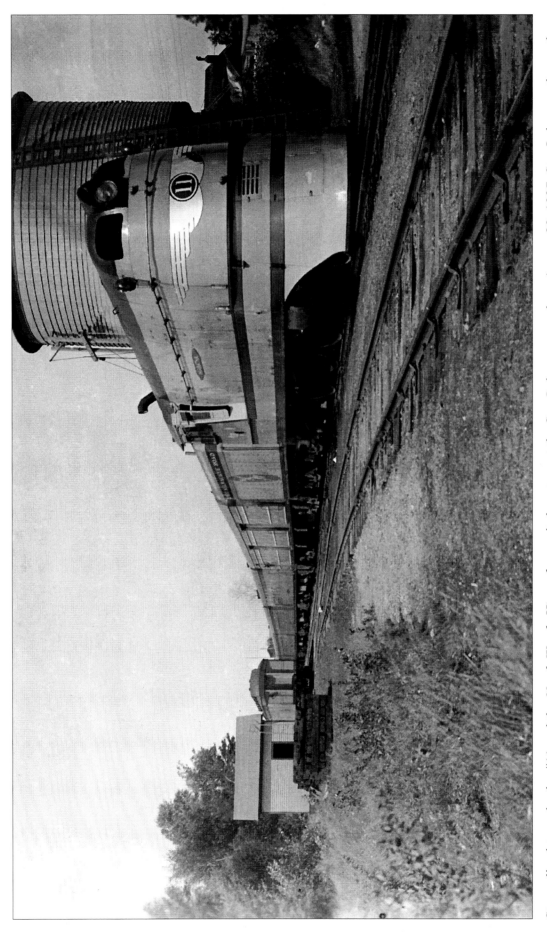

Streamlined ten-wheeler #11 and the *North Woods Hiawatha* await departure at the Star Lake water tank on August 29, 1937. Star Lake was the northern terminus of the train; #11 typically handled it between Star Lake and Wausau, and #10 took it between Wausau and New Lisbon.

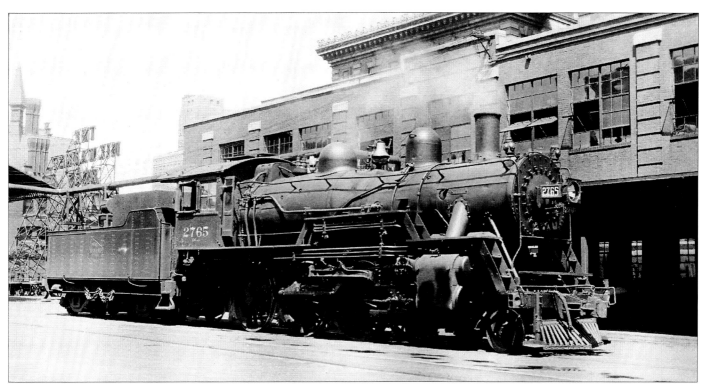

Class G6ps #2765 suns itself outside the post office annex next to Milwaukee's Everett Street depot in August 1934. It was rebuilt in 1925 from B3 class compound #4206 (BLW c/n 18081), and had 22" x 26" cylinders, 69" drivers and 200 psi boiler pressure, with a tractive effort of 31,004 pounds. In 1937 it was rebuilt into shrouded G class #11 to pull the *North Woods Hiawatha.*

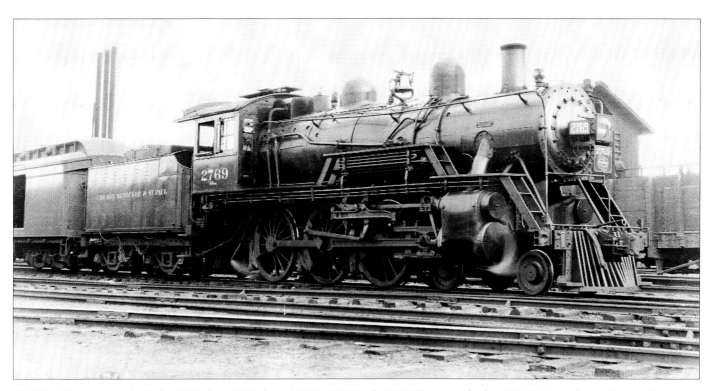

#2769, G6ps class rebuilt in 1926 from B3 class #4215 (BLW c/n 18157) wears the late 1920's lettering scheme. It was rebuilt into G class shrouded #10 in 1936 for use on the *North Woods Hiawatha.* The new train made its first run on Sunday, October 11, and #10 was displayed at the Wausau depot on October 14, 1936.

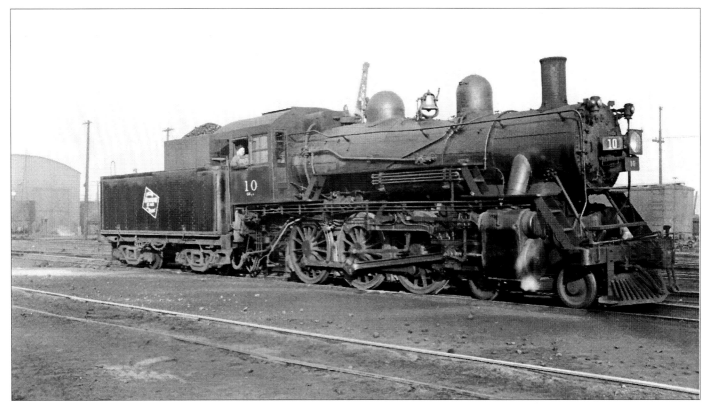

In 1945 the ten-wheelers had been replaced by streamlined Pacifics, and had their shrouding removed to become conventional ten-wheelers. #10 is at Chicago on December 7, 1945. It finished its career in suburban service,

#11 is at Chicago the same date. The two would soon be renumbered #1111 (#10) and #1112 (#11). Both were scrapped in 1951.

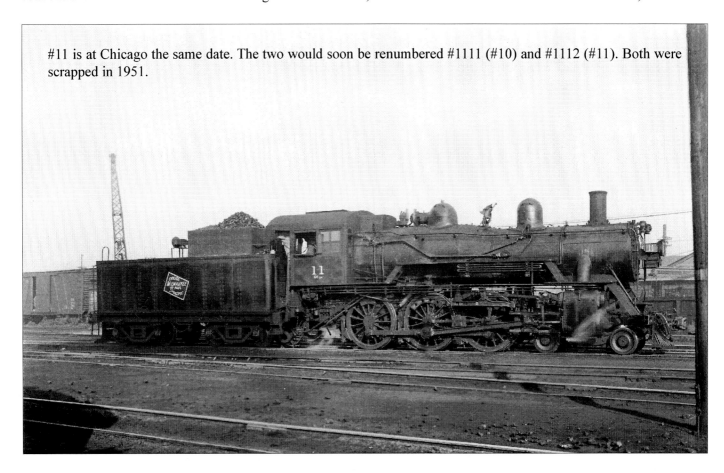

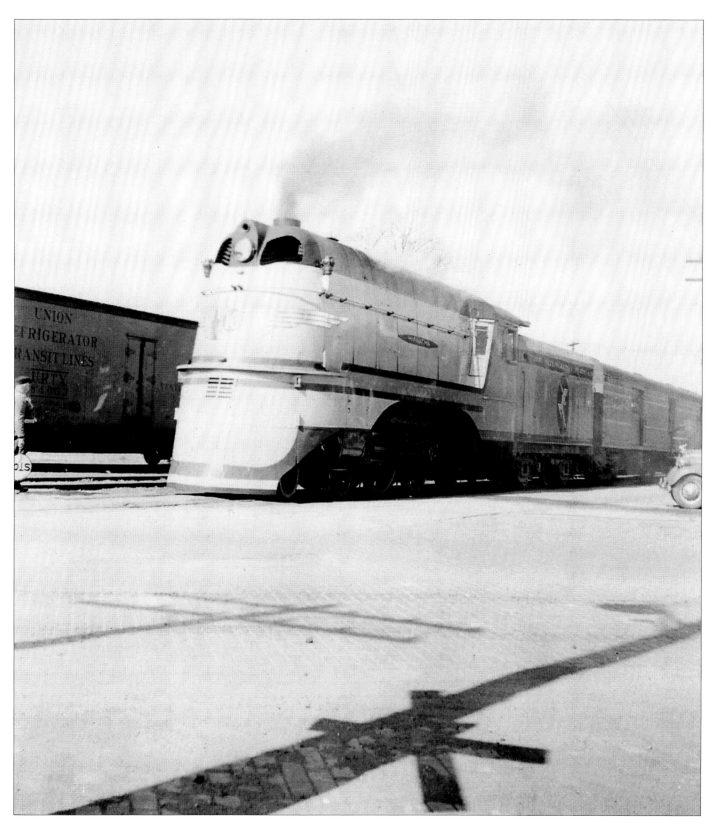
Shrouded #10 waits at the Wisconsin Rapids depot crossing on April 12, 1939. Its skirting has been cut away by this time. Though it looks fast, and its train was luxurious, the *North Woods Hi* schedule averaged 35-40 mph between Wausau and New Lisbon.

Pacifics

Since Pacifics were the Milwaukee's regular mainline passenger locomotives, it was only natural that they were used when the road needed to supplement its fleet of Speedliners. They were used in shrouded, semi-streamlined, and brightly painted versions as protection and for second sections of the mainline *Hiawathas*, to pull the Manilla to Sioux Falls section of the *Midwest Hiawatha*, to handle the *North Woods Hiawathas* as trains became heavier, and to power the *Chippewa Hiawathas*. F3 class #150, #151 and #152 and F5 class #801 and #812 all wore shrouds. #6160 received sheet metal semi-shrouding for the main line trains, and several conventional Pacifics were painted in orange, maroon and gray and lettered for *Chippewa Hiawatha* service.

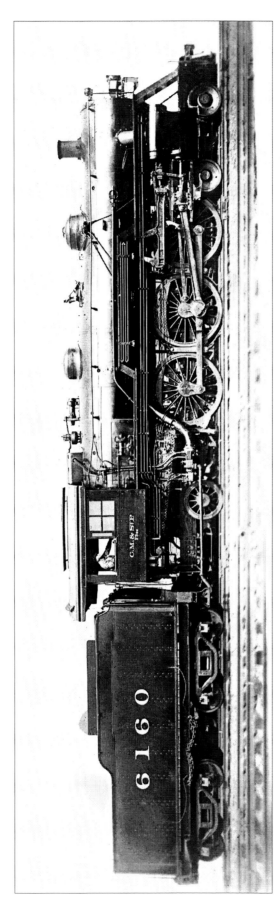

F3 Pacific #6160 (Alco 1910 c/n 47482) was selected as protection power for the initial two Speedliner Atlantics. An engineer poses in the cab in a shop photo of #6160 in its early configuration, with original tender. Converted to burn oil and given an Atlantic-style tender, it was typically stationed at the depot turntable in case there was a problem with #1 or #2 coming up from Chicago, and it handled second sections as needed.

THE SPEEDLINERS

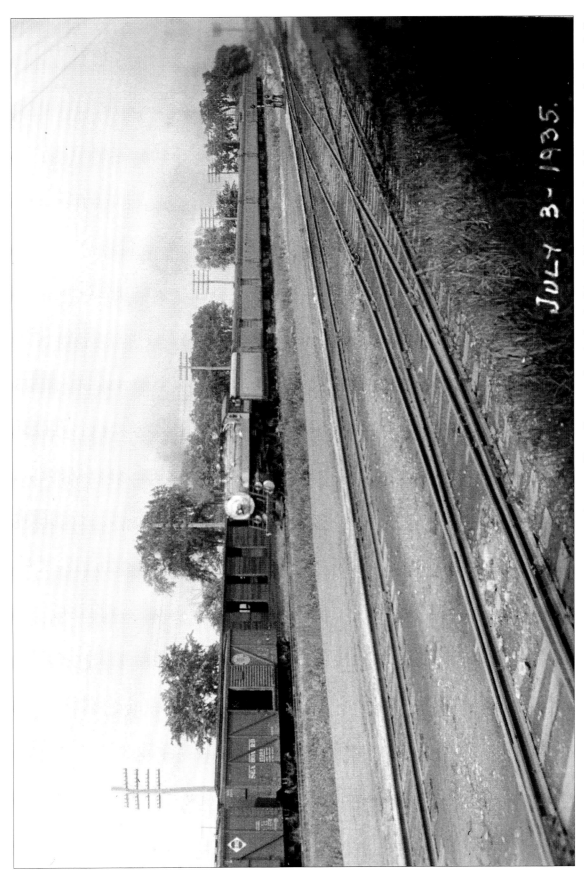

When the *Hiawathas* inaugurated service on May 29, 1935, the Speedliner fleet consisted of only #1 and #2. With both of these committed to daily operation between Chicago and the Twin Cities, there was no back-up for extra maintenance or second sections if needed. F3 class "star" Pacific #6160 (the star locomotives regularly ran in Chicago-Milwaukee service) was selected and given modified streamlining and orange and gray *Hiawatha* paint. Slightly over a month after the inauguration, #6160 pulls second No. 101 at Brookfield on July 3, 1935. Milwaukee Road photo.

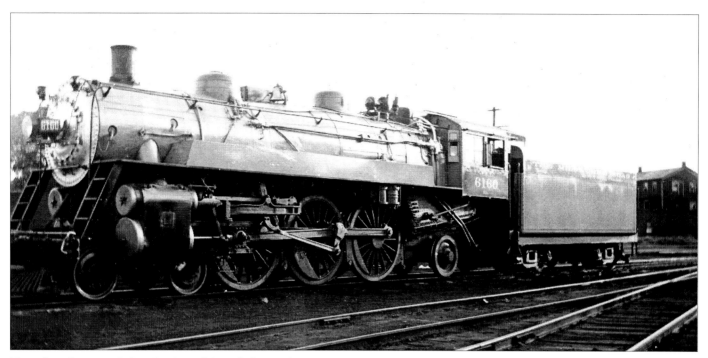

Two days later, on July 14, 1935, #6160 is in service at LaCrosse. The fireman's side shows more sheet metal, stars on the cylinders, and a solid disk trailing wheel. Kenneth Zurn photo.

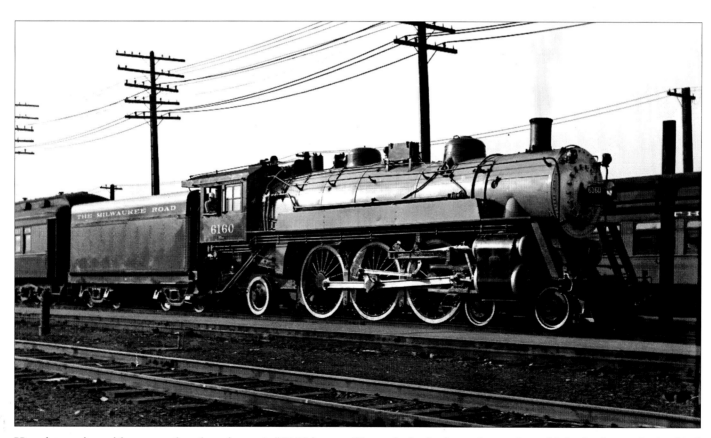

Here in service with conventional equipment, #6160 has no *Hiawatha* insignia on the tender, which also has only 4-wheel trucks instead of one 6-wheel truck on the Atlantics.

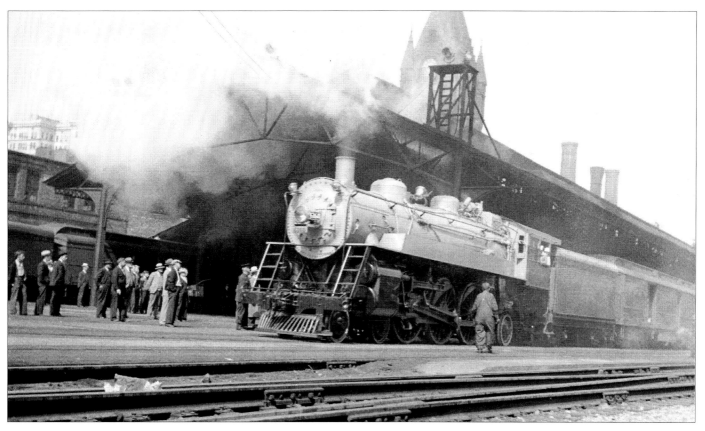
Onlookers examine #6160 pulling into the Milwaukee depot with a conventional train.

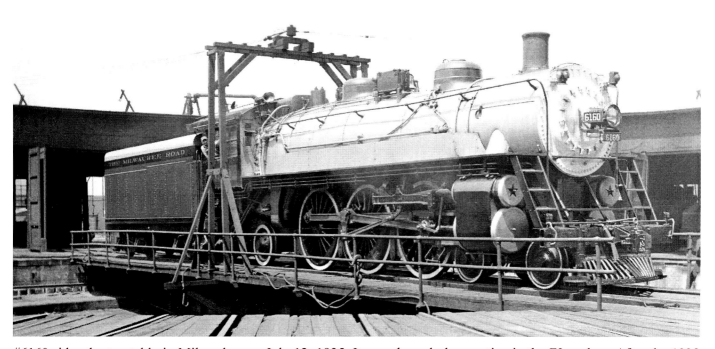
#6160 rides the turntable in Milwaukee on July 12, 1935. It was the only locomotive in the F3cs class. After the 1938 system-wide renumbering it became #152, later receiving more extensive shrouding.

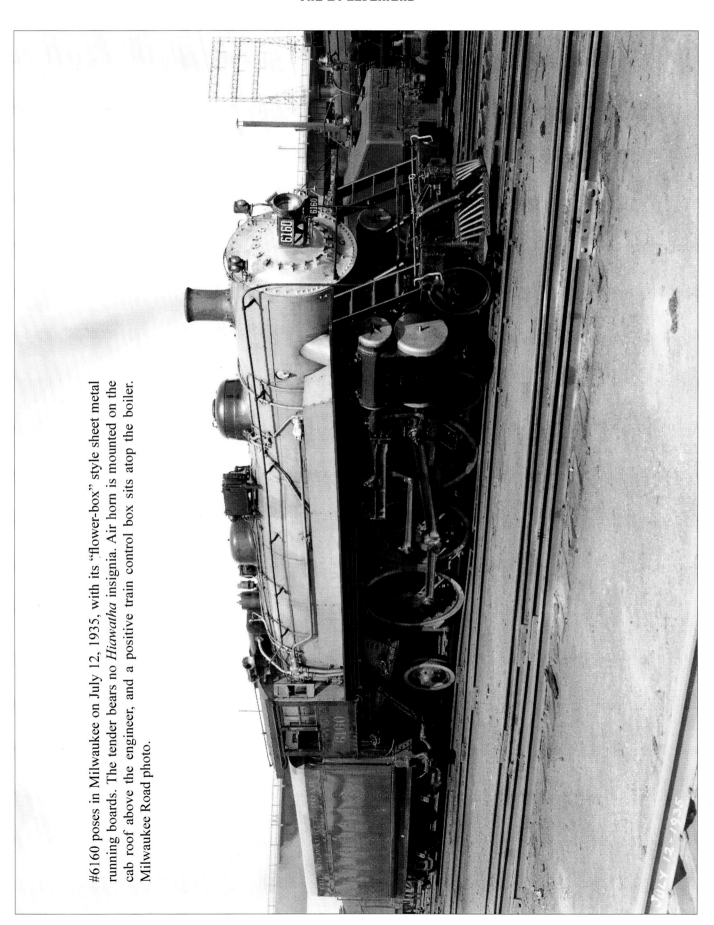

#6160 poses in Milwaukee on July 12, 1935, with its "flower-box" style sheet metal running boards. The tender bears no *Hiawatha* insignia. Air horn is mounted on the cab roof above the engineer, and a positive train control box sits atop the boiler. Milwaukee Road photo.

The Speedliners

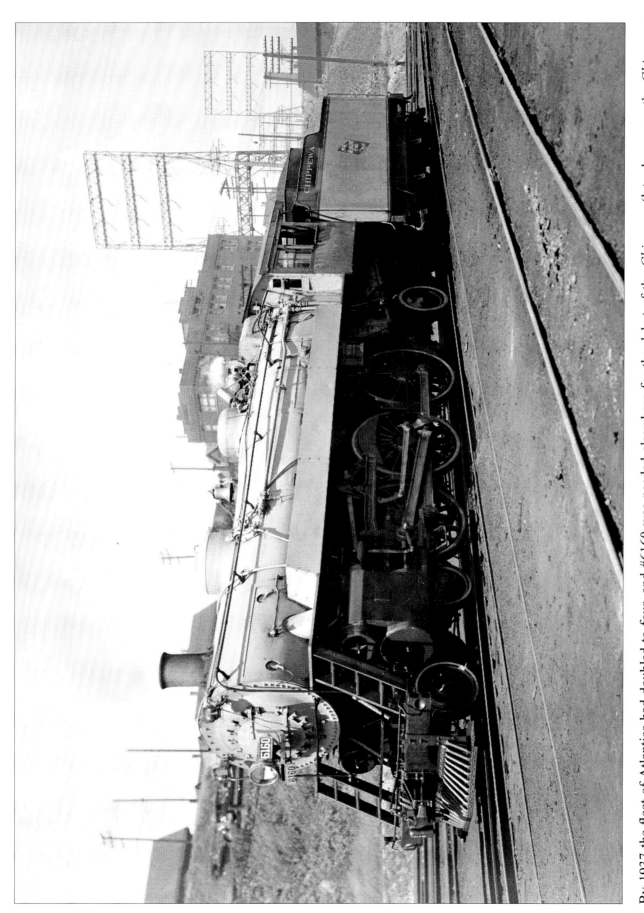

By 1937 the fleet of Atlantics had doubled to four, and #6160 was needed elsewhere for the debut of the *Chippewa* (later known as the *Chippewa Hiawatha*) which was introduced in the company magazine as a fast streamlined train. Here at Milwaukee on June 24, 1937, #6160 has a new paint scheme, has been reconverted to burn coal (there were no locomotive oiling facilities on the Superior Division) and equipped with a coal tender. Instead of a *Hiawatha* insignia, the tender carries a CMStP&P herald which was standard practice at the time. Milwaukee Road photo.

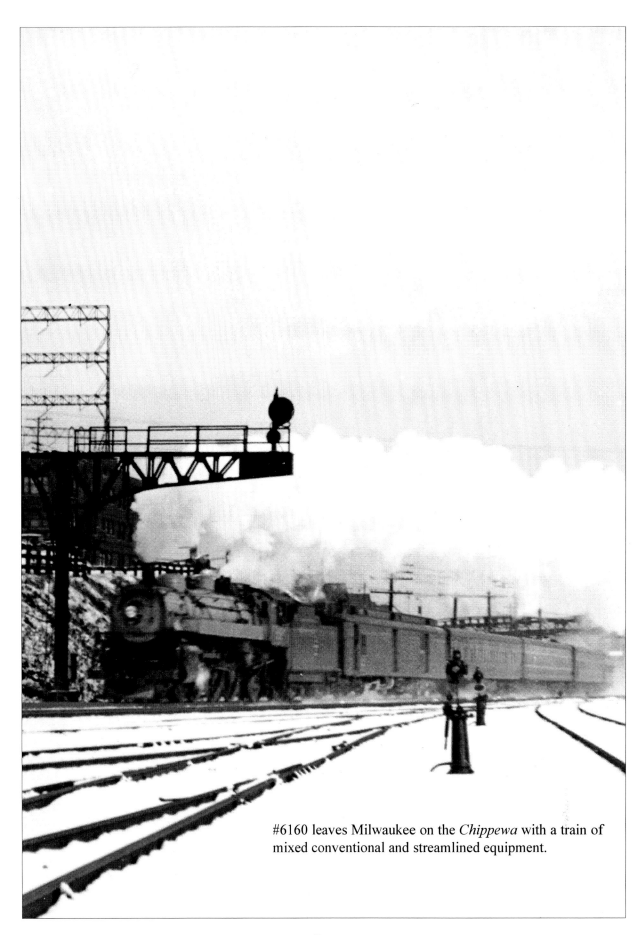

#6160 leaves Milwaukee on the *Chippewa* with a train of mixed conventional and streamlined equipment.

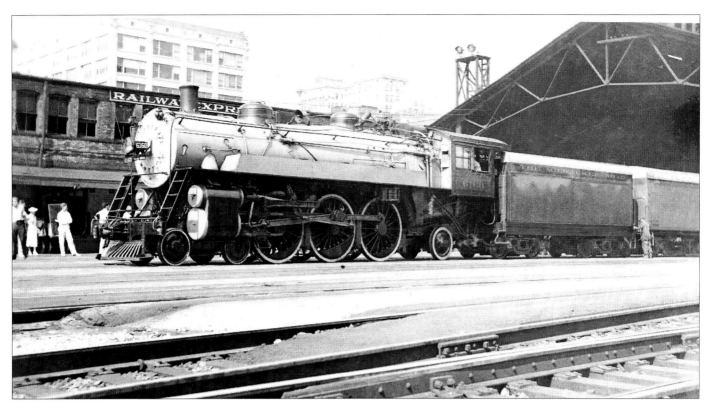

The photo identifies this as #6160 on the *Chippewa* in July 1937; the oil tender and *Hiawatha* streamlined equipment suggest that #6160 may be on a very early or inaugural run, since there were no oiling facilities and it would need to make a round trip. Spectators at the depot rarely were disappointed in the activity there.

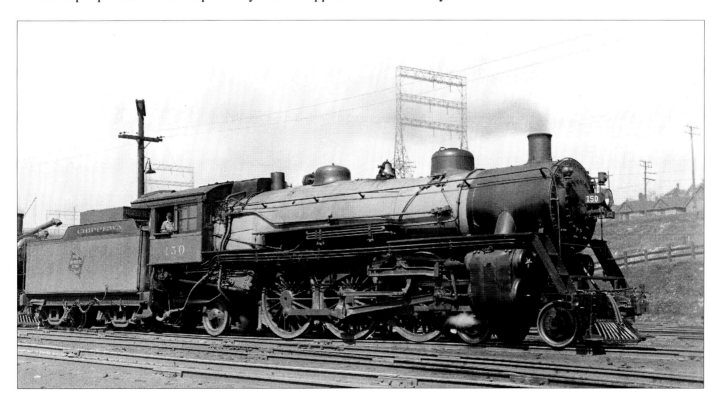

#150 (Alco 1910 c/n 48723) is painted for Chippewa service and ready for work at Milwaukee in 1941. It would later be fully shrouded similar to the F7 Hudsons.

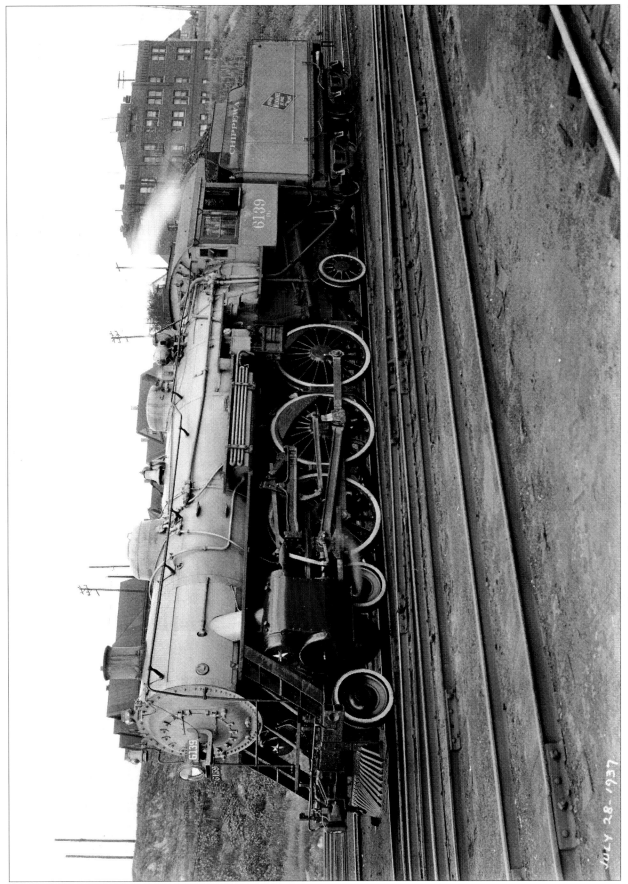

Another star Pacific painted for *Chippewa* service was #6139 (Alco 1912 c/n 47461), here posing at Milwaukee on July 28, 1937. Milwaukee Road photo.

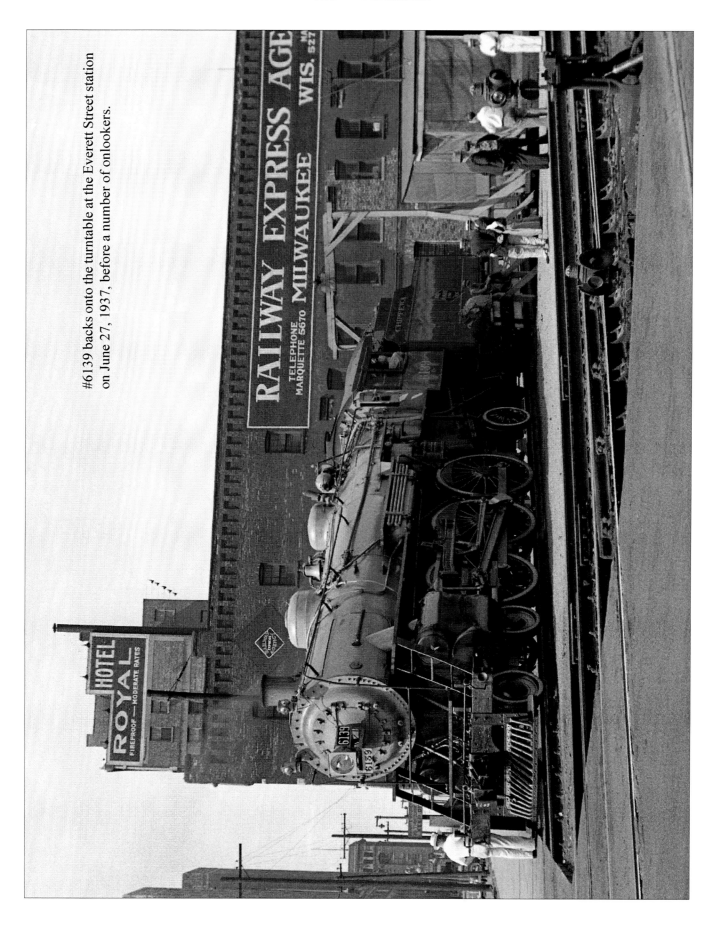

#6139 backs onto the turntable at the Everett Street station on June 27, 1937, before a number of onlookers.

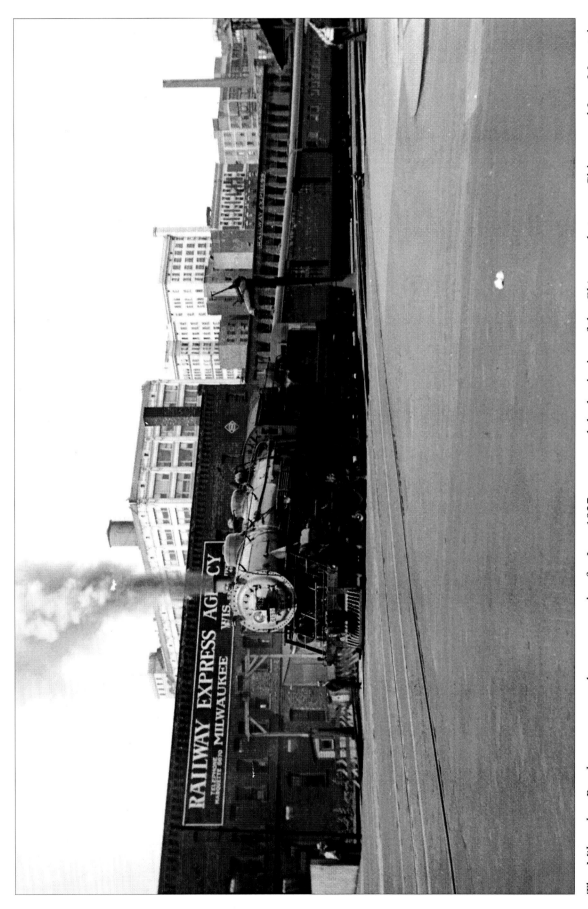

The *Milwaukee Road* company employees magazine for June 1937 announced the beginning of the *Chippewa* between Chicago and Iron Mountain, Michigan, as a "new streamlined train, brightly hued, with luxury lounge, coaches, a parlor and dining car, all air-conditioned." The train's name, the result of a contest, was suggested because of the already existing connection of Milwaukee trains to Indian lore, and the area traversed. It was exhibited between Milwaukee and Green Bay on May 26, and Green Bay and Iron Mountain the following day.

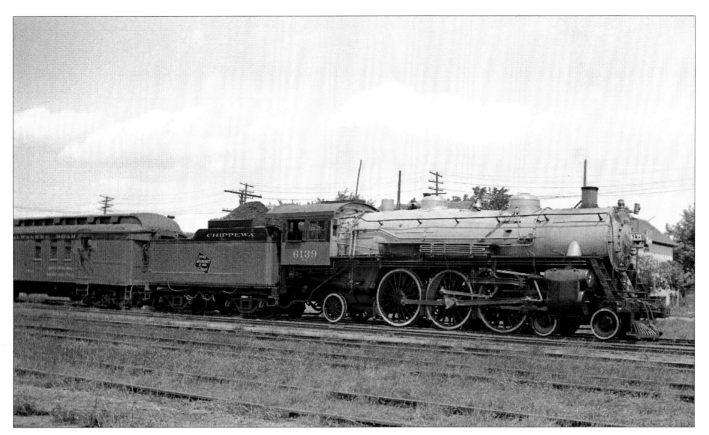
#6139 poses at Iron Mountain with a full coal load on July 2, 1937.

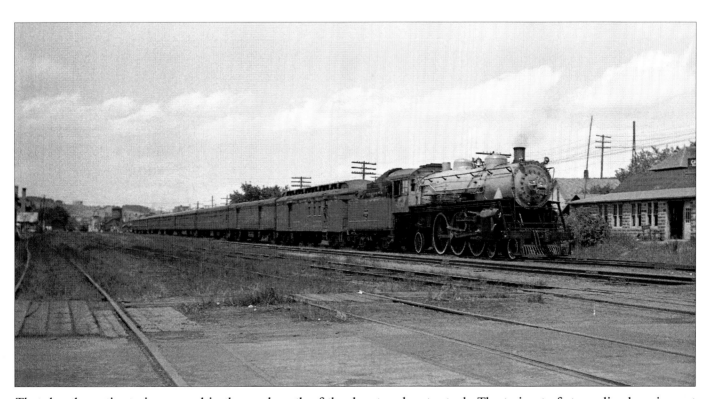
That day the entire train reposed in the yard south of the depot and water tank. The trainset of streamlined equipment carries a conventional RPO.

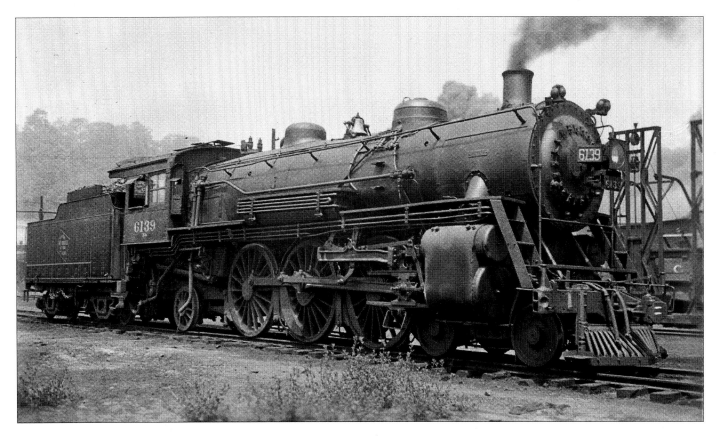

#6139 is in its original look at St. Paul, Minnesota, in the early 1930's, before acquiring its colorful paint for the *Chippewa*. Milwaukee Road photo.

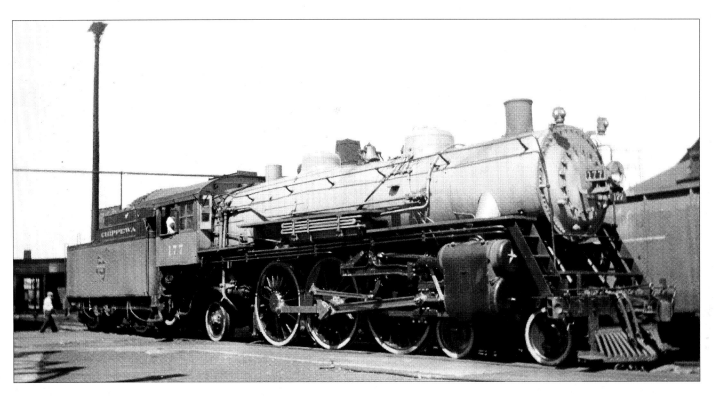

Engineer's side of star Pacific #177 in Chippewa paint.

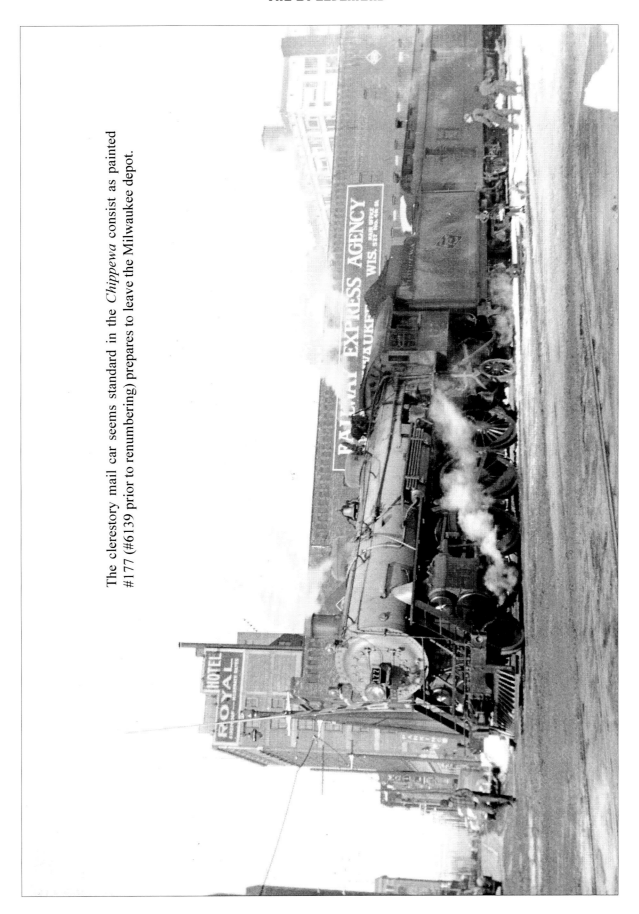

The clerestory mail car seems standard in the *Chippewa* consist as painted #177 (#6139 prior to renumbering) prepares to leave the Milwaukee depot.

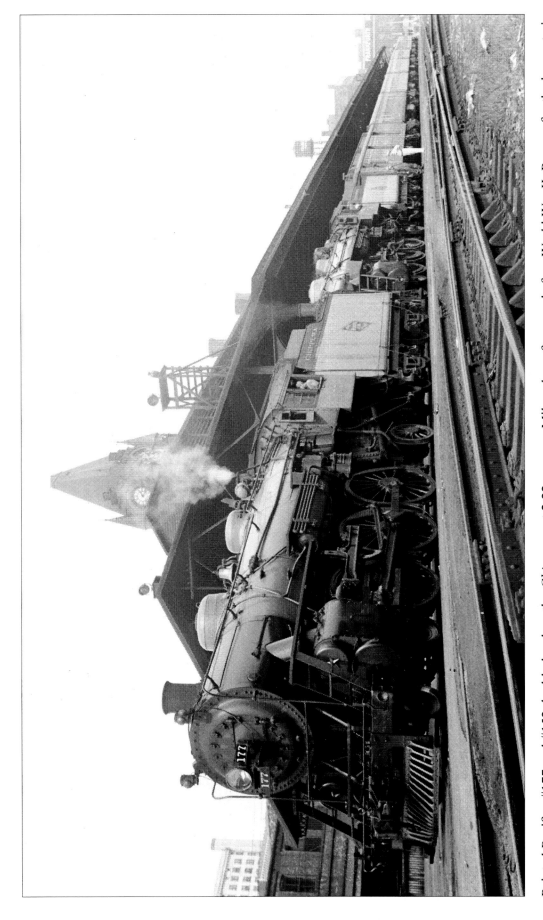

Painted Pacifics #177 and #152 double-head on the *Chippewa* at 2:22 pm on a Milwaukee afternoon before World War II. Reason for the heavy train and need for double-heading is not known, though double heading rather than using two sections would save on one train crew.

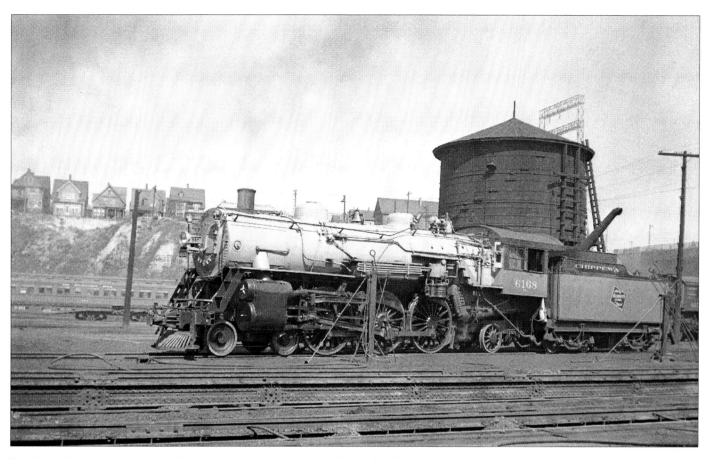

#6168 (Alco 1912 c/n 47490) has a fresh coat of colorful paint for the *Chippewa* in March 1938. It would soon be renumbered #197. The color scheme is gray boiler jacket, maroon below running board, with orange cab and tender.

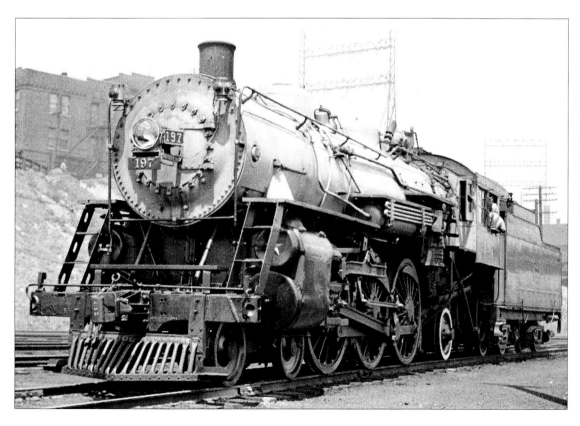

The fireman watches the tracks as #197 backs at Milwaukee. #197 has been renumbered from #6168.

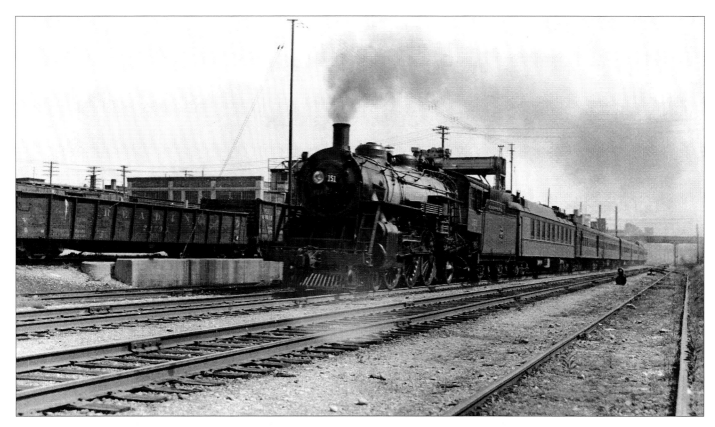

F3s class #151 in gray and orange paint takes train No. 21, the *Chippewa,* north out of Milwaukee on July 4, 1941. The train contains a sleeping car to be set out at Pembine, Wisconsin, for the Soo Line. #151 received shrouding and was reclassed F1; it was scrapped in 1954. A Howard Christiansen photo.

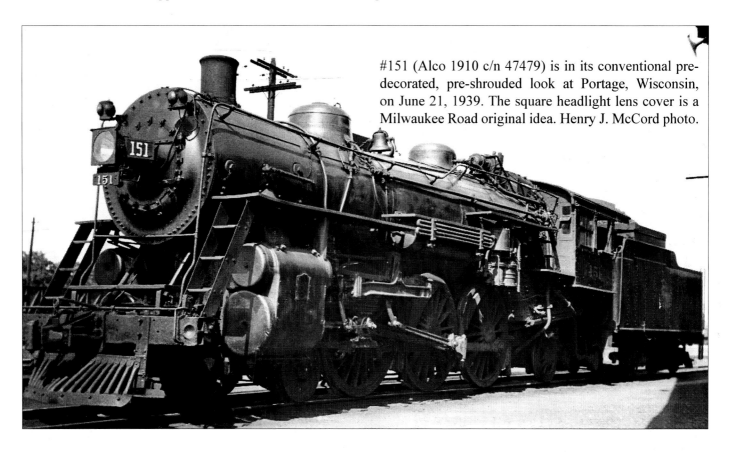

#151 (Alco 1910 c/n 47479) is in its conventional pre-decorated, pre-shrouded look at Portage, Wisconsin, on June 21, 1939. The square headlight lens cover is a Milwaukee Road original idea. Henry J. McCord photo.

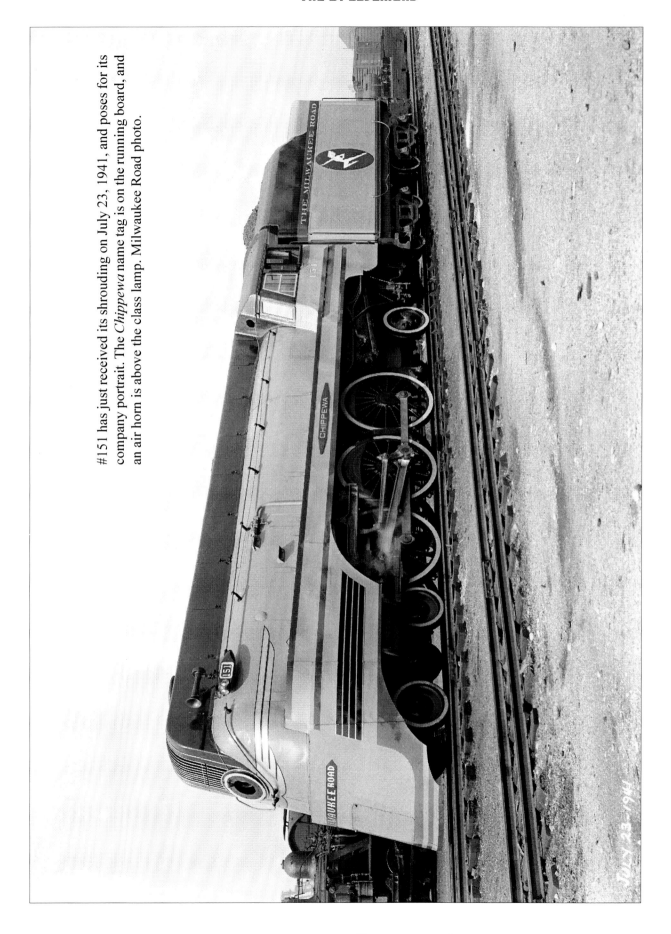

#151 has just received its shrouding on July 23, 1941, and poses for its company portrait. The *Chippewa* name tag is on the running board, and an air horn is above the class lamp. Milwaukee Road photo.

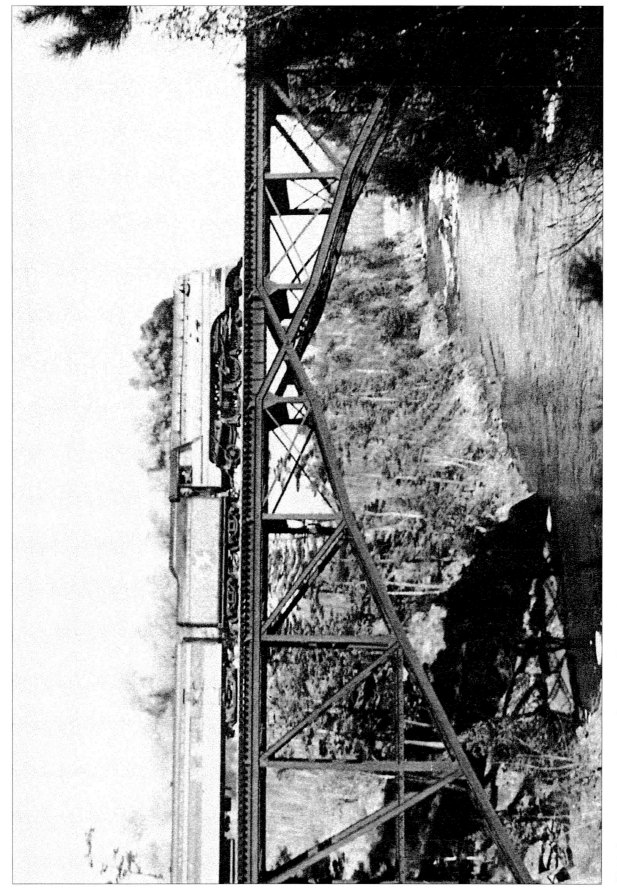

#151, by summer 1947 wearing Speedliner-style shrouding, crosses the Menominee River between Michigan and Wisconsin 2 ½ miles south of Iron Mountain on the southbound *Chippewa*. The engineer is Charles Donlevy. Otto Bell photo.

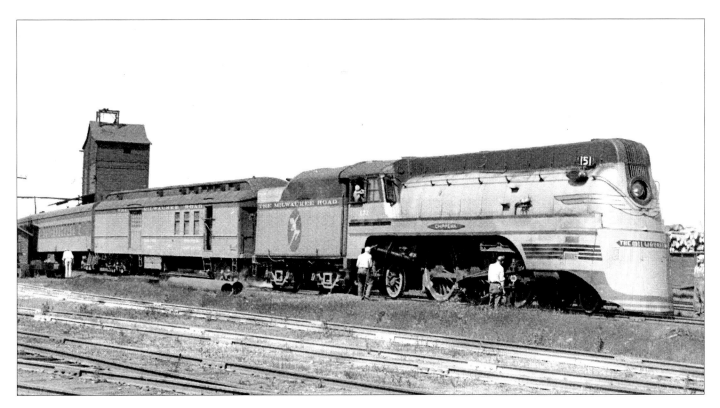

Shrouded #151 is on train No. 14 at Channing, Michigan, on August 7, 1947. The clerestory RPO at least wears orange paint. Rev. E.A. Batchelder photo.

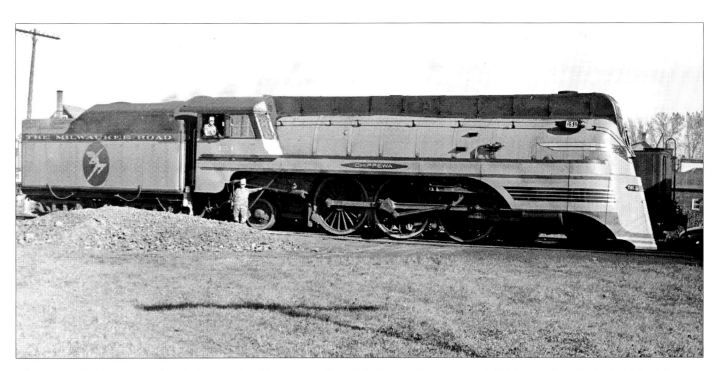

The crew of #151 poses with their steed beside a large pile of cinders at Ontonogon, Michigan. Though the initial *Chippewa* was announced as terminating at Iron Mountain, Ontonogon became the terminus.

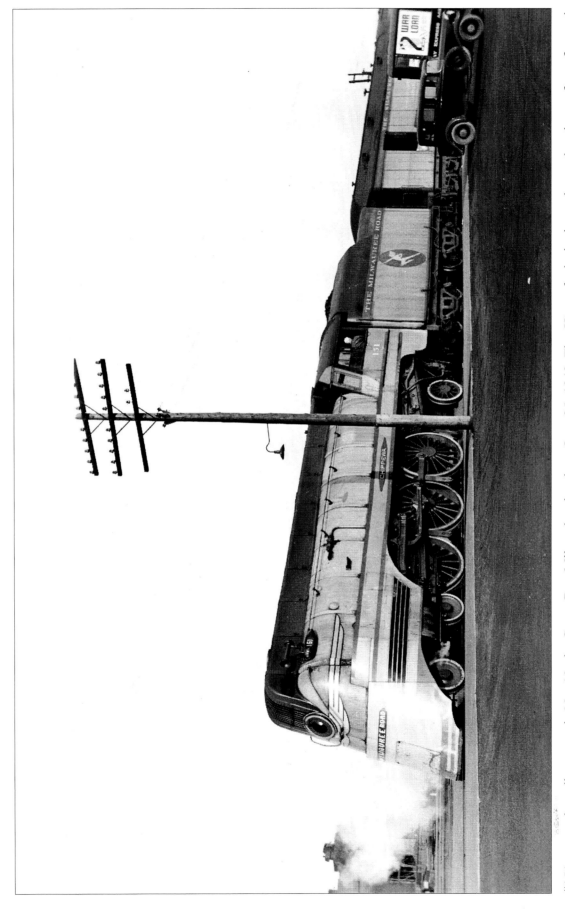

#151 wears shrouding on train No. 10, the Green Bay-Milwaukee local, on June 25, 1943. The *Hiawatha* insignia on the tender always faces forward. A. Howard Christiansen photo.

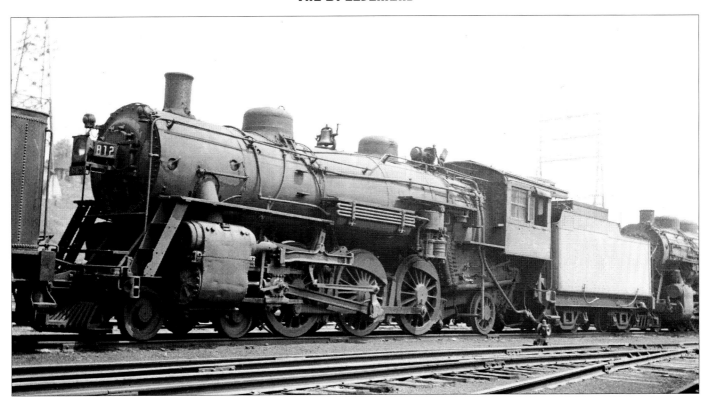

Conventional F5 Pacific #812 (Alco 1912 c/n 51154) at Milwaukee would soon receive shrouding for use on the *Midwest Hiawatha's* Sioux Falls section. The *Midwest Hi* was inaugurated on December 11, 1940, running from Chicago to Manilla, Iowa, where it split into two sections for Omaha and Sioux Falls.

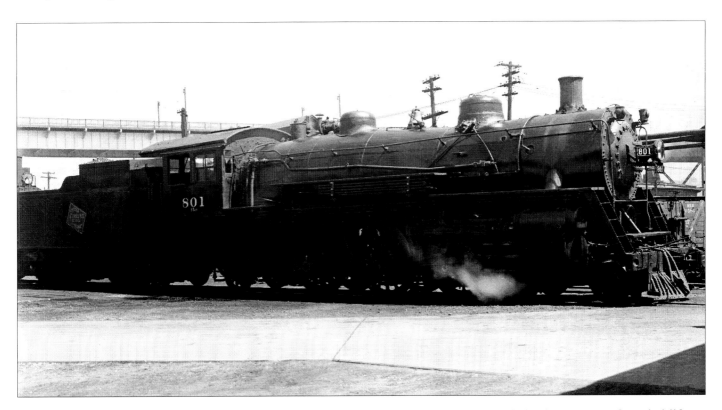

#801 (Alco 1912 c/n 51135) is also in its conventional dress on July 3, 1940. It would also have a new shrouded life on the *Midwest Hiawatha.* Milwaukee Road photo.

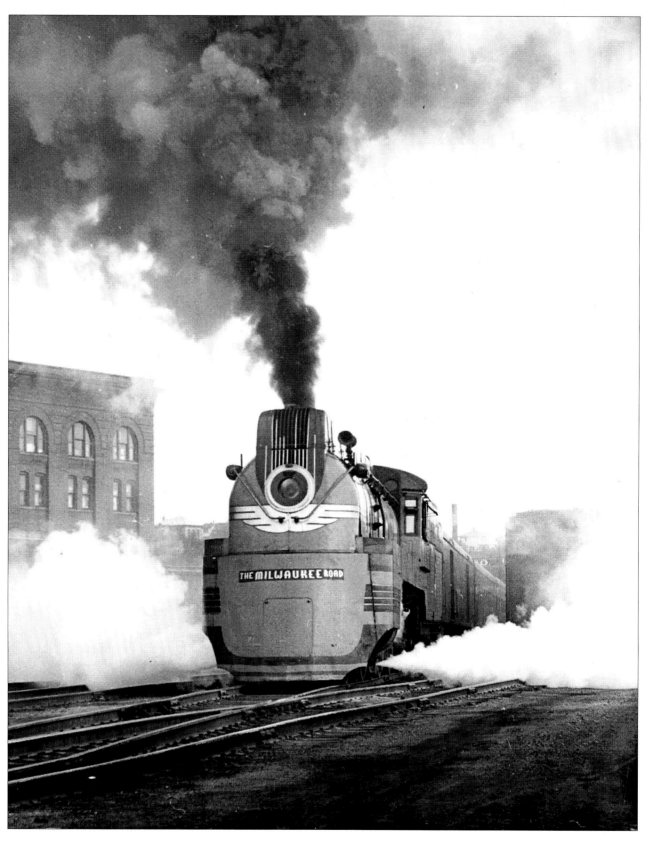

Streamlined #801 blows its cylinder cocks while getting underway at Sioux Falls, South Dakota, on the *Midwest Hiawatha* in 1944. The air horn is prominently located on the fireman's side beside the cowling. Henry J. McCord photo.

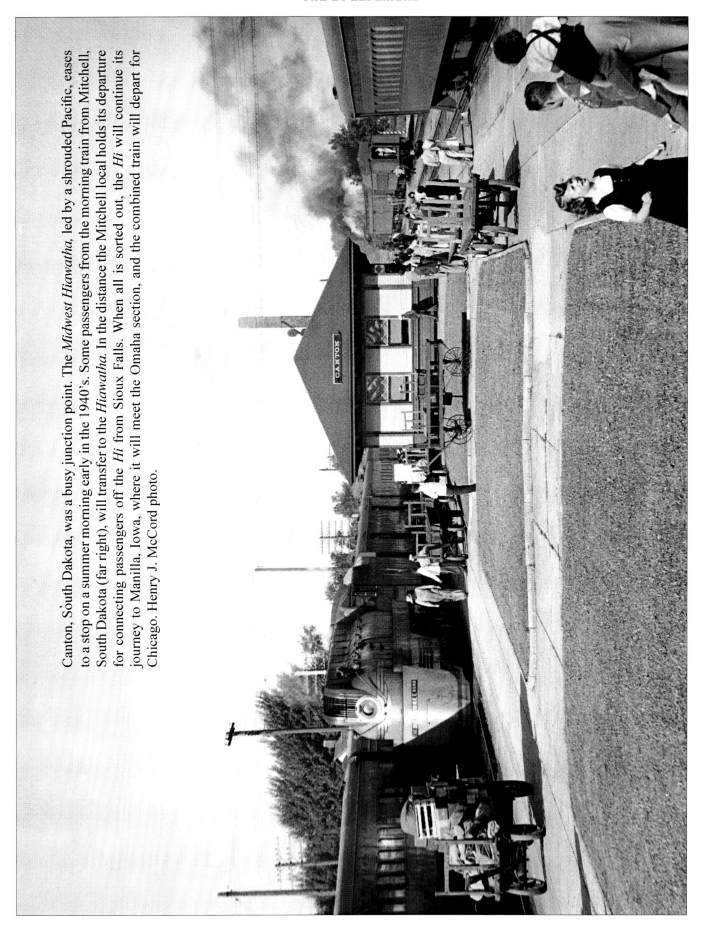

Canton, South Dakota, was a busy junction point. The *Midwest Hiawatha*, led by a shrouded Pacific, eases to a stop on a summer morning early in the 1940's. Some passengers from the morning train from Mitchell, South Dakota (far right), will transfer to the *Hiawatha*. In the distance the Mitchell local holds its departure for connecting passengers off the *Hi* from Sioux Falls. When all is sorted out, the *Hi* will continue its journey to Manilla, Iowa, where it will meet the Omaha section, and the combined train will depart for Chicago. Henry J. McCord photo.

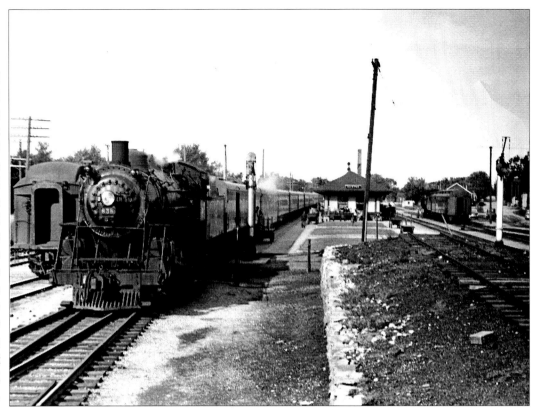

The *Sioux, Arrow,* and *Midwest Hiawatha* all passed through Canton on their routes between Sioux Falls and Chicago. F5 Pacific #838 (Alco 1912 as #1538) leads the eastbound *Midwest Hiawatha,* which has arrived and is spotted at the standpipe on the south main line while baggage and passengers are exchanged. The branchline train at right is probably one of the twice-daily mixed trains, which met the eastbound named trains at Canton. Henry J. McCord photo.

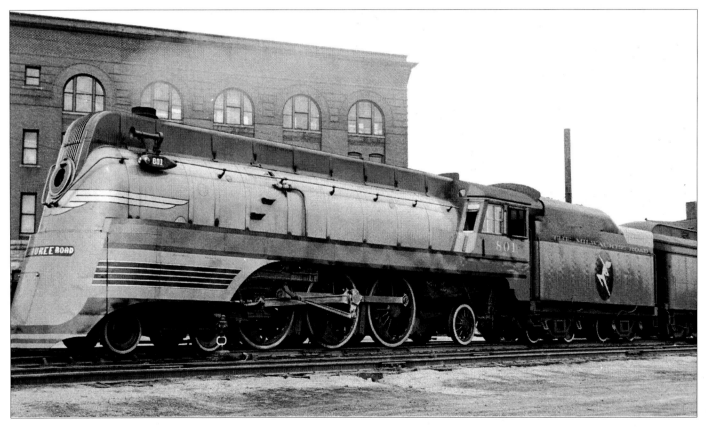

Shrouded Pacific #801 leads the *Midwest Hiawatha* at Sioux Falls, the train's western terminus. #801 and #812 received F7-like shrouds in 1941 for use on the Sioux Falls-Manilla section of the train. Alco constructed #801 in 1912 as F5 class #1523; it was soon renumbered #6301 and carried this number until becoming #801 in 1938, when it was reclassed F2. It pulled the *Midwest Hi* until 1946 and was scrapped in 1950. Henry J. McCord photo.

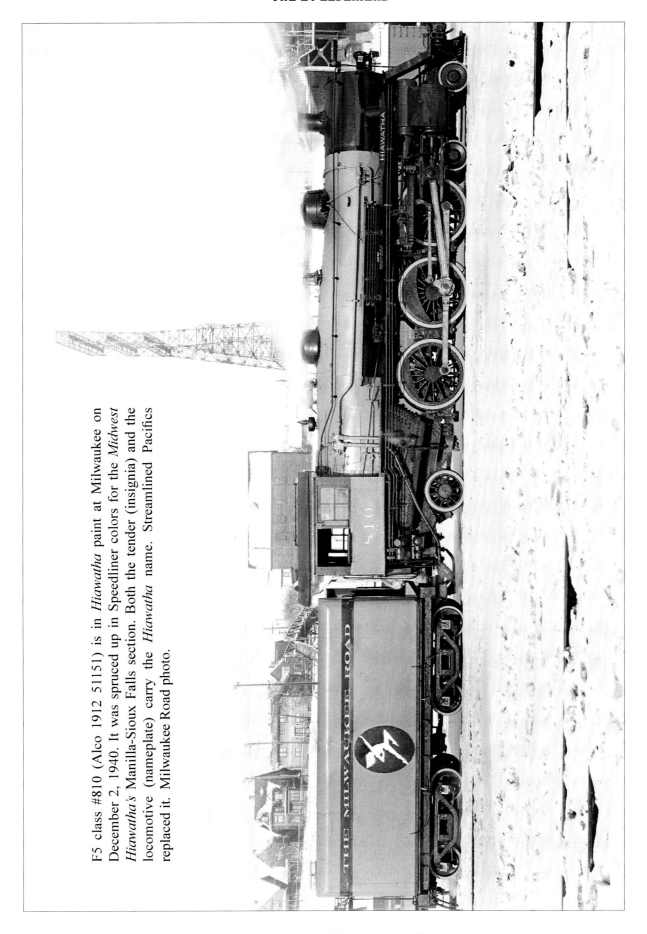

F5 class #810 (Alco 1912 51151) is in *Hiawatha* paint at Milwaukee on December 2, 1940. It was spruced up in Speedliner colors for the *Midwest Hiawatha*'s Manilla-Sioux Falls section. Both the tender (insignia) and the locomotive (nameplate) carry the *Hiawatha* name. Streamlined Pacifics replaced it. Milwaukee Road photo.

Passenger Cars

One of the factors involved in the Milwaukee's selection of conventional trains of individual cars rather than permanently coupled train units was the ability of its own car shops to turn out trains of cars as needed. As soon as the 1934-1935 cars went into service, new trains of the 1936 design followed, and in 1938 trains of rib-side cars went into service behind the F7 Hudsons. As new cars went into main line service, the older ones were switched to service on the *North Woods Hiawatha* and *Midwest Hiawatha*.

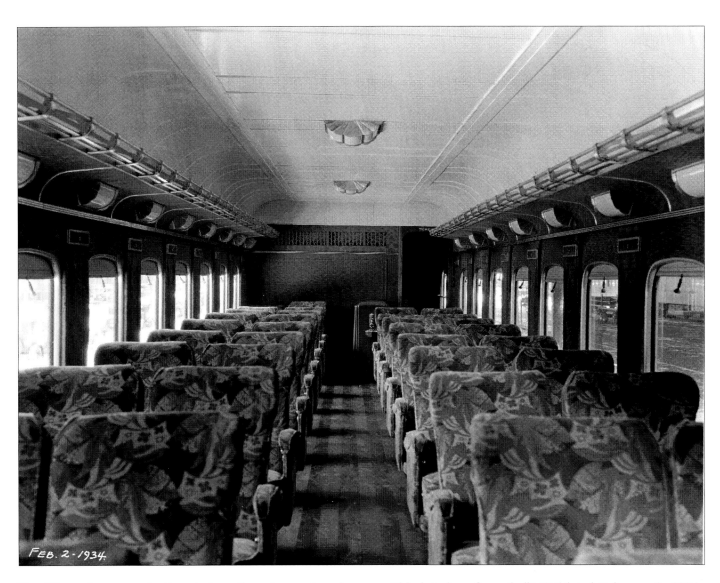

The *Hiawathas* were daytime trains of coaches and parlor cars. This interior of coach #4400 dated February 2, 1934, reflects seating for 40 in the main section. The men's smoking lounge offered even more seating. The plush upholstered seats revolved, had reclining seat backs, and offered passengers more space and a more comfortable ride. They had larger luggage racks, direct lighting above each seat, and a forced air ventilating system, soon to be replaced by air conditioning. #4400 was displayed at the Chicago Century of Progress exhibit in 1934 as "The Progress Coach". Milwaukee Road photo.

The Speedliners

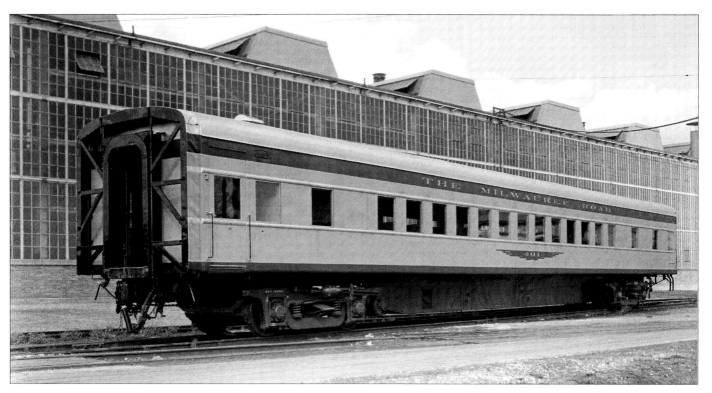

Coach #401 from the second group of cars, constructed in 1936, has full-width diaphragms for even less air resistance. Milwaukee Road photo.

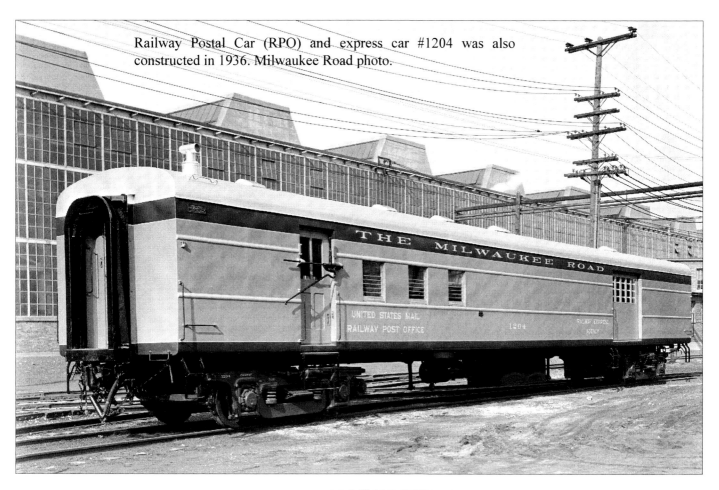

Railway Postal Car (RPO) and express car #1204 was also constructed in 1936. Milwaukee Road photo.

THE SPEEDLINERS

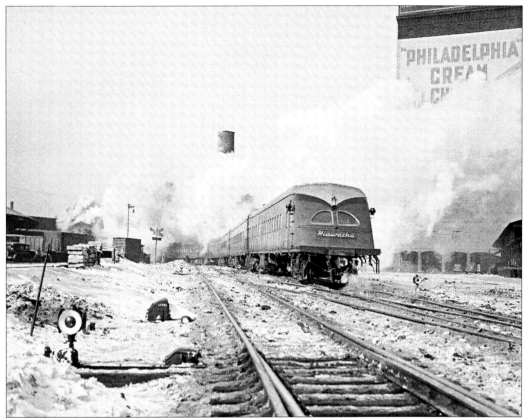

An original *Hiawatha* Beaver Tail observation car carries the markers leaving Chicago at Canal and Lake Streets on February 11, 1936. The air horn above the rear windows is for back-up moves into the stub-ended terminals at Chicago and Minneapolis. The snow is strewn with soot and cinders from passing locomotives.

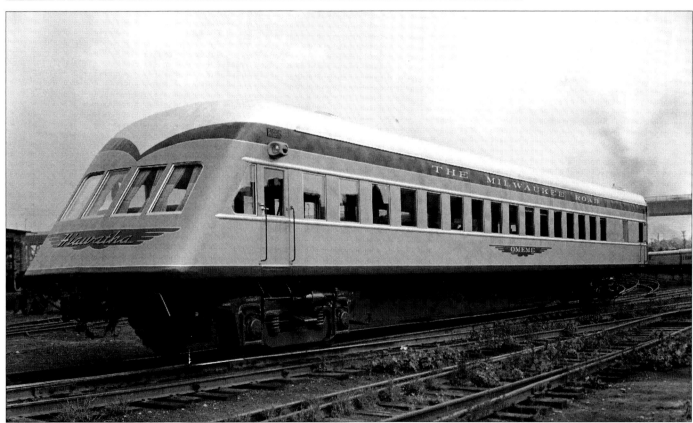

Omeme was among the second group of Beaver Tail cars constructed. The rear windows were changed to full width in an attempt to take more advantage of the passing scene behind. The small door is for a brakeman who may need to get out and flag. Milwaukee Road photo.

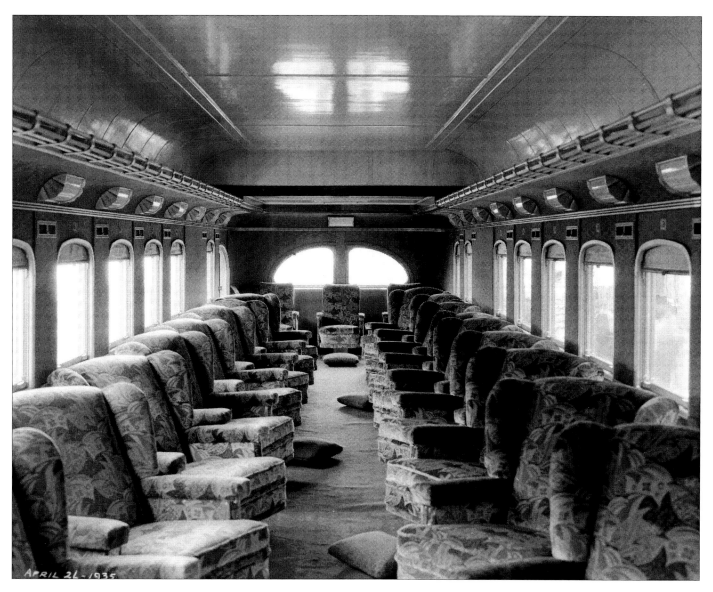

The date of April 26, 1935 is just weeks before arrival of Speedliners #1 and #2, and of the inauguration of *Hiawatha* service on May 29. The sumptuous interior of one of the original Beaver Tails has individual rotating parlor car chairs and foot pillows. The tail windows reflect automotive rear window design of the era, but failed to take advantage of the rearward view. Milwaukee Road photo.

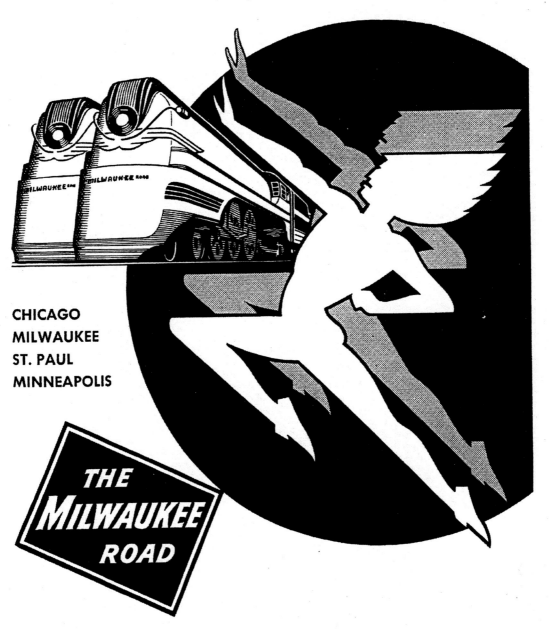

Roster of Speedliner Locomotives

Class	Orig. Class	#	wheel arr.	Blt.	Bldr.	Renumbering	Sc.
A	A	**1**	4-4-2	1935	Alco	-	1951
		2	"	1935	Alco	-	1951
		3	"	1936	Alco	-	1949
		4	"	1937	Alco	-	1951
G	B3/G6	**10**	4-6-0	1900	Baldwin	315/1615/4215/ 2769/**11**/1112	1951
	"	**11**	"	1900	Baldwin	306/1606/4206/ 2765/**10**/1111	1951
F7	F7	**100**	4-6-4	1938	Alco	-	1949
		101	"	"	Alco	-	1951
		102	"	"	Alco	-	1950
		103	"	"	Alco	-	1951
		104	"	"	Alco	-	1951
		105	"	"	Alco	-	1951
F1	F3	**150**	4-6-2	1910	Alco	1511/6109/**150**	1951
		151	"	1910	Alco	1539/3237/6537/6157/**151**	1954
		152	"	1910	Alco	1542/3240/6540/**6160**/152	1954
F2	F5	**801**	"	1912	Alco	1523/6301/**801**	1950
F2		**812**	"	1912	Alco	1542*/6320/**812**	1950
	F5	**810**	"	1912	Alco	1539*/6317/**810**	1952
F3		**177**	"	1910	Alco	1521/3219/6519/**6139**/177	1951
F3		**197**	"	1910	Alco	1550/3248/6548/**6168**/197	1954

Bold numbers are Speedliners.
* = (second use of this number)

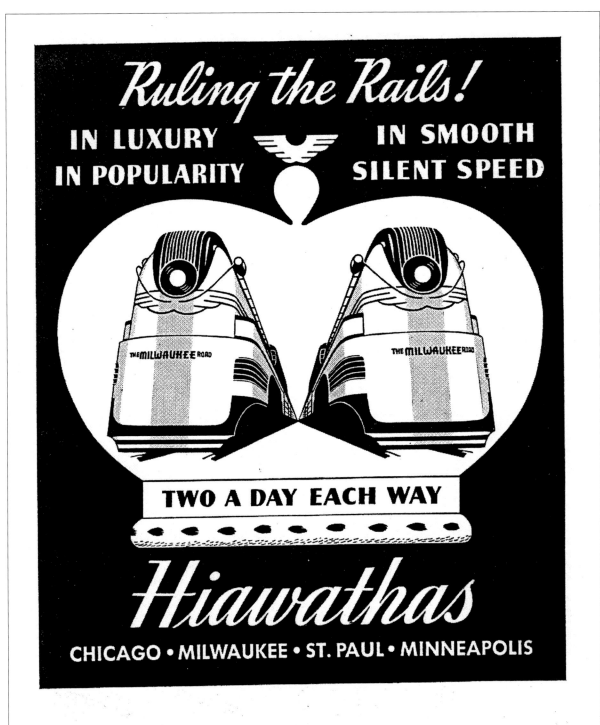

The streamliners with a distinctive character all their own

BIBLIOGRAPHY

Bilty, Charles H. *The Story of the Hiawatha.* Milwaukee. Milwaukee Road Railfans Association. Milwaukee County Historical Society. 1985.

Burg, Thomas E. and Bob Storozuk. *Route of the North Woods Hiawatha.* Merrill, Wisconsin. Merrill Publishing Associates. 2010.

Burg, Thomas E. *The Milwaukee Road Steam Era in Wisconsin; Vol. 1, The Main Line.* Merrill. Merrill Publishing Associates. 2012.

Burg, Thomas E. *Windy City Steam.* Merrill. Merrill Publishing Associates. 2011.

Dorin, Patrick C. *The Milwaukee Road Passenger Train Services.* Forest, Virginia. TLC Publishing, Inc. 2004.

Gruber, John and Brian Solomon. *Milwaukee Road's Hiawathas.* St. Paul. MBI Publishing Company. 2006.

Kelly, John. *Streamliners to the Twin Cities Photo Archive.* Hudson, Wisconsin. Iconografix. 2002.

Milwaukee Road Locomotives. Railroad History No. 136. Boston. The Railway and Locomotive Historical Society, Inc Spring 1977.

Model Railroader (magazine). Milwaukee. Kalmbach Publishing Co. (numerous issues)

Railroad Magazine. New York. The Frank A. Munsey Co. (numerous issues)

Scribbins, Jim. *The Hiawatha Story.* Milwaukee. Kalmbach Publishing Co. 1970.

Solheim, Carl W. *Hiawatha, First of the Speedliners.* Milwaukee. The Milwaukee Shops, Inc. 1993.

Tigges, John. *Milwaukee Road Steam Power.* Transportation Trails. 1994,

Trains (magazine). Milwaukee. Kalmbach Publishing Co. (numerous issues)

The Milwaukee Magazine (employees magazine). (numerous issues)

OTHER PUBLICATIONS BY MERRILL PUBLISHING ASSOCIATES

Other books from the Roy Campbell Collection:
Wisconsin Shortline & Logging Steam, Photos from the Roy Campbell Collection, 2009
The C&NW Steam Era in Wisconsin, Photos from the Roy Campbell Collection, 2009
Burlington Route Steam, Photos from the Roy Campbell Collection, 2008
Milwaukee Road – Steam in the West, Photos from the Roy Campbell Collection, 2008
Soo Line Steam, Photos from the Roy Campbell Collection, 2008
Early 20th Century Rock Island Steam, Photos from the Roy Campbell Collection, 2008
The Green Bay & Western Steam Era, Photos from the Roy Campbell Collection, 2008
Chicago's Steam Suburbans, Photos from the Roy Campbell Collection, 2007
Green Mountain Steam, Historic Vermont Railroading, Photos from the Roy Campbell Collection, 2011
South Shore Steam, Locomotives of the Duluth, South Shore & Atlantic Railway and Mineral Range Railroad,
 Photos from the Roy Campbell Collection, 2011
Milwaukee Road Steam Era, Volume 1: The Main Line, Photos from the Roy Campbell Collection, 2012
Milwaukee Road Steam Era, Volume 2: Secondary & Branch Lines, Photos from the Roy Campbell Collection, 2013

Other books:
Route of the North Woods Hiawatha, The Milwaukee Road's Wisconsin Valley Line, 2010
Davenport Locomotive Works Catalog (CD version also available)

Merrill Publishing Associates also produces books for the Milwaukee Road Historical Association. Nine volumes (of a planned series of 10) have been produced to date. (see www.mrha.com)
Milwaukee Road Steam Locomotives, Volume I, S Class Northerns, 2005, MRHA
Milwaukee Road Steam Locomotives, Volume II, F6 Class Hudsons, 2006, MRHA
Milwaukee Road Steam Locomotives, Volume III, F1-F5 Class Pacifics, 2007, MRHA
Milwaukee Road Steam Locomotives, Volume IV, J, I, and D Class Switchers, 2007, MRHA
Milwaukee Road Steam Locomotives, Volume V, L Class Mikados, 2008, MRHA
Milwaukee Road Steam Locomotives, Volume VI, C Class Consolidations, 2009, MRHA
Milwaukee Road Steam Locomotives, Volume VII, B and G Class Ten-Wheelers, 2010, MRHA
Milwaukee Road Steam Locomotives, Volume VIII, Transition Designs, A Class Atlantics and K Class Prairies. 2011, MRHA
Milwaukee Road Steam Locomotives, Volume IX, H Class and Pre-classification Americans, 2012, MRHA
Milwaukee Road Steam Locomotives, Volume X: Speedliners, 2014 MRHA and Merrill Publishing Associates

Other books by Thomas E. Burg:
WHITE PINE ROUTE, The History of the Washington, Idaho & Montana Railway Company, 2003 Museum of North Idaho, Coeur d'Alene, Idaho

Other books by Sharon Thatcher:
ON THE LASER'S EDGE, The Conspiracy: Code Word Tikal (with Thomas E. Burg), 2006 Merrill Publishing Associates
HISTORY OF MERRILL, WISCONSIN: The Jenny Years, 1847-1881, 2000 Merrill Historical Society, Merrill, Wisconsin
Edited by Sharon Thatcher: *THE RANGERS' REIGN: A Glimpse of Semi Pro Baseball in the '50s,*
 by Louis Paetsch and Michael Weckwerth, 2004

For more information contact us at: contact@merrillpublishingassociates.com
Merrill Publishing Associates, P.O. Box 51, Merrill, WI 54452